DOORS OF VENICE
Views of a Vanishing City

GREG MILLER

SCHIFFER
PUBLISHING

4880 Lower Valley Road • Atglen, PA 19310

Other Schiffer Books on Related Subjects:

Secret Cities of Italy: 60 Charming Towns off the Beaten Path, Thomas Migge, 978-0-7643-6591-1

Decorative Ironwork of Italy, Photography by Augusto Pedrini, 978-0-7643-3399-6

Copyright © 2025 by Greg Miller

Library of Congress Control Number: 2024942485

All rights reserved. No part of this work may be reproduced or used in any form or by any means—graphic, electronic, or mechanical, including photocopying or information storage and retrieval systems—without written permission from the publisher.

The scanning, uploading, and distribution of this book or any part thereof via the Internet or any other means without the permission of the publisher is illegal and punishable by law. Please purchase only authorized editions and do not participate in or encourage the electronic piracy of copyrighted materials.

"Schiffer," "Schiffer Publishing, Ltd.," and the pen and inkwell logo are registered trademarks of Schiffer Publishing, Ltd.

Cover design by Alexa Harris

Type set in Sinete/Minion Pro

ISBN: 978-0-7643-6880-6

ePub: 978-1-5073-0531-7

Printed in China

Published by Schiffer Publishing, Ltd.
4880 Lower Valley Road
Atglen, PA 19310
Phone: (610) 593-1777; Fax: (610) 593-2002
Email: info@schifferbooks.com
Web: www.schifferbooks.com

For our complete selection of fine books on this and related subjects, please visit our website at www.schifferbooks.com. You may also write for a free catalog.

Schiffer Publishing's titles are available at special discounts for bulk purchases for sales promotions or premiums. Special editions, including personalized covers, corporate imprints, and excerpts, can be created in large quantities for special needs. For more information, contact the publisher.

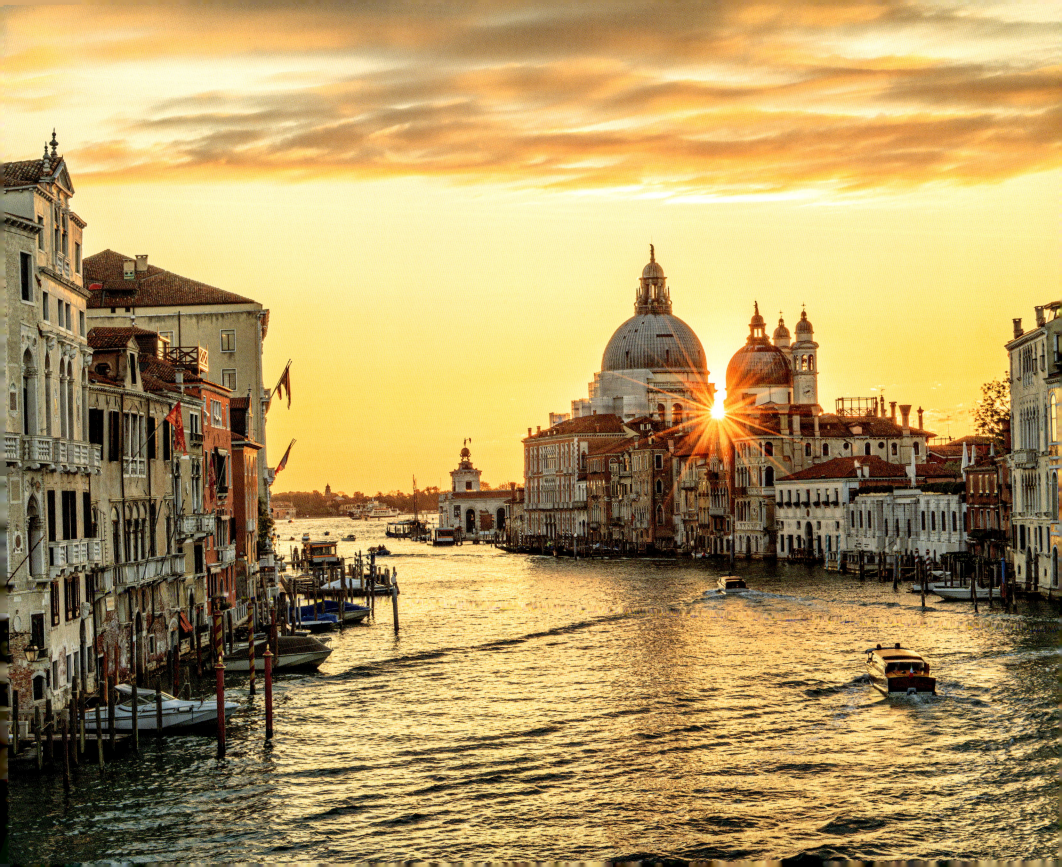

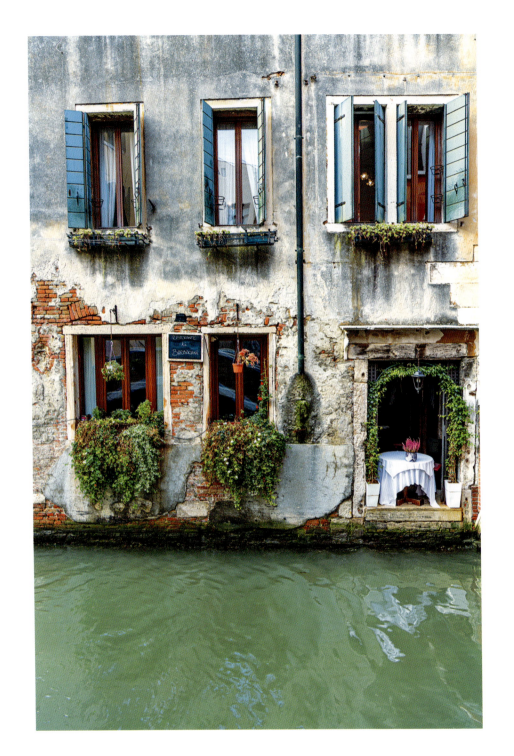
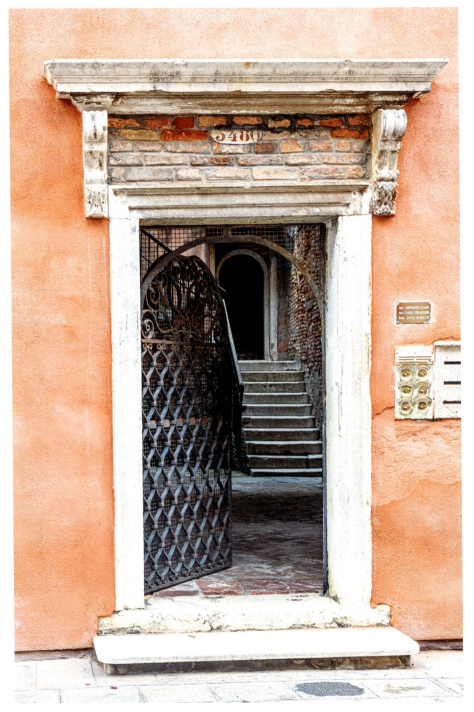

Author's Note

Venice. *La Serenissima*. Truly a magical city.

I have been to Venice a number of times, and the city grabs me more than any other. Narrow walkways with historic architecture. No cars. You can easily imagine yourself there hundreds of years ago. And the light—like a slot canyon in Utah, the light bounces around the "canyons" of the city in enchanting and unpredictable ways. I always left my visits feeling frustrated, with a strong yearning to stay longer in a silent alley and wait for the light to work its wonder.

I have always had a sense of the magical power held by doors. In Venice, this magic is palpable because there is so much history, so many memories, so much color. Here, the doors tell a story.

Venice is overrun by tourists, disguising the fact that the population of native Venetians has been steadily declining. Today's population of Venice is less than 50,000. In the past seventy years, 70 percent of Venetians have left the city, while tourism brings larger and larger numbers of foreigners. As the residents age out or leave for better job prospects, well-heeled foreign investors are buying homes and apartments at prices locals can no longer afford. My experience was that it is hard to see true Venetians in Venice. During the day, tourists throng the narrow streets. Mostly, I saw locals only in the morning, walking their children to school, or in the evening, in off-the-beaten-path restaurants.

But the doors! The doors are everywhere, and they tell a story of the people who live behind them. From centuries of worn paint to well-preserved and opulent wood and metal, the doors flaunt their beautiful colors and rich patinas. Aside from being interesting objects, the doors tell us about who Venetians—both ancient and current—are. But as more and more Venetians leave the city and the homes are turned into short-term rentals, the doors—these precious centurions of time—are bound to be lost. It became a mission for me that while the masses of tourists were out walking to see the obvious sights, I was out walking to see what the doors could tell me about the Venetians past and present.

By putting together this book, I hope to visually preserve the doors and their stories, for all to see, to savor, to wonder. I hope you will find this journey as compelling and magical as I did when making the photos.

Buon viaggio!

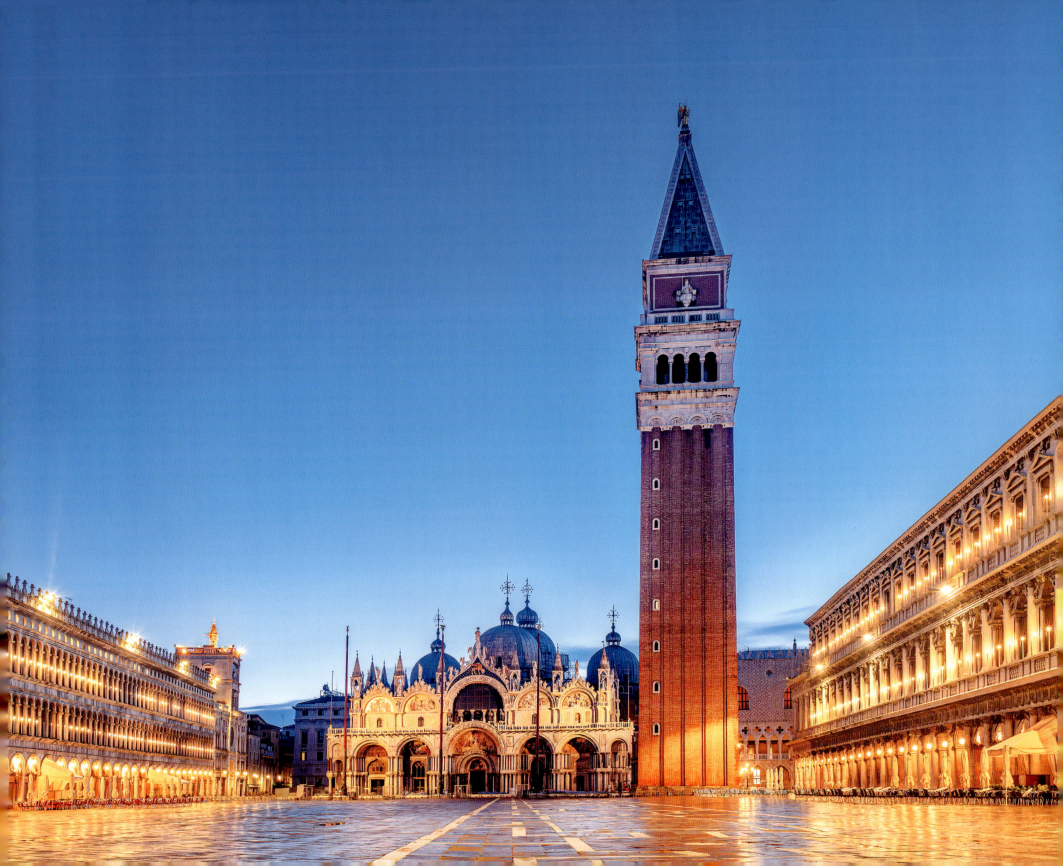

An Introduction to Venice

A lagoon, 118 islands linked by 436 bridges, sixteen centuries of history, and some twenty-three million tourists per year: This is Venice.

To the average visitor, Venice is a chaotic labyrinth. Crossing the Rialto Bridge at noon or waiting in the queue for St. Mark's Basilica means enduring crowds. The options for moving around are either walking or going by boat. Getting lost is par for the course, and avoiding tourist traps can be a challenge.

How best to enjoy this city? Make time. You will need at least one day to properly experience Venice, and walking will be your best option. A panoramic ride on a water taxi may give you magnificent memories, but in Italy we say that the best way to discover Venice is to get lost in it by walking.

Most of the city is quite calm, almost deserted. You'll find mesmerizing subjects for photography if you leave the beaten track. Many tourists focus on Rialto and St. Mark's Square—and these places are must-sees, but there is a lot more to Venice. If you are willing to explore the city early in the morning or by night, you will find magic.

A prerequisite for a good time in Venice is to choose what you're interested in. Seeing the city from the top of a bell tower? Climbing the golden staircase and the Senate Hall in the Doge's Palace? Taking a lesson in mask making? Touching the silken lace on Burano Island? Tasting the tiramisù in a pastry shop? Gazing at the ceiling in the Scuola Grande di San Rocco? Seeing where the patricians of old lived?

To understand this city, we need to look at its past and to understand its birth, rise, and downfall. Why build a city on the water? The answer is desperation and survival. The collapse of the Western Roman Empire and the barbaric invasions caused refugees to flee the mainland and to seek shelter in the Venetian lagoon. Safety meant putting water between themselves and the barbarians. Thus, Venice was born: a small village hidden in a lagoon difficult to navigate, huts roofed with marsh reeds, and wooden poles reinforcing the frail banks.

Opposite: Piazza San Marco

From the eleventh to the fifteenth centuries, Venice made its fortune by trading spices. A city on the water bred intrepid sailors and wily merchants. They traded pepper, ginger, cloves, nutmeg, and cinnamon—buying in the East at cheap prices and selling at handsome profits in the West. Venice became a metropolis and a commercial hub that provided a critical economic link between the Christian and the Muslim kingdoms, and the beyond of Asia and Africa.

Wealth permitted the city to be decorated and embellished by fine artists of the day: Bellini, Titian, Tintoretto, Veronese, Palladio, Codussi, Sansovino, and Longhena.

As a world power built on world trade, you will see in Venice evidence of many cultures, induing Africa, Asia, and the Middle East.

Geographical explorations initiated the downfall of Venice. Portuguese merchants discovered the way to reach India by circumventing Africa, thus ending the Venetian monopoly on spices, while the discovery of America by Christopher Columbus in 1492 changed the ancient world. From the fourteenth century onward, the rise of the Spanish Empire in the West and the Ottoman Empire in the East slowly but surely strangled Venice.

After losing their grip on trade, the Venetian ruling classes tried military adventurism. But that didn't stop the city's decline. A series of wars against the Ottoman Empire for the prize of Greece resulted in pyrrhic victories, if not crushing defeats—and all at bankrupting expenses. The final end for the Venetian state came in 1797, when Napoleon conquered the city. A period of foreign dominion (first the French, then the Austrians) lasted until 1866, when Venice became part of the Italian kingdom.

.

—Roko Cupic

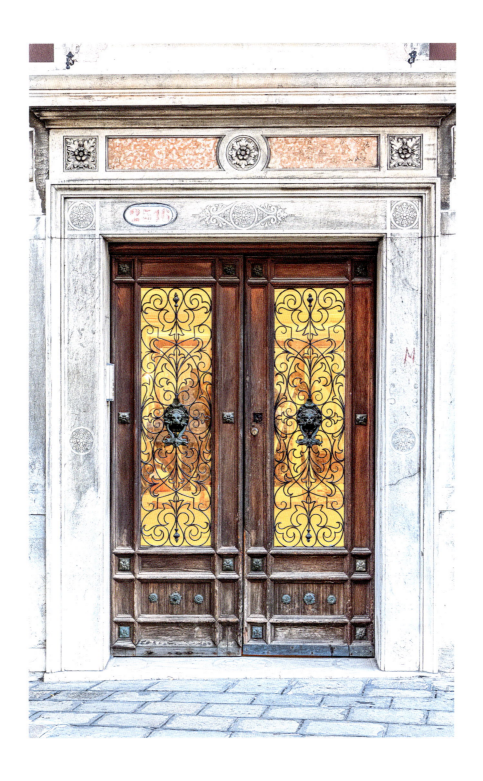

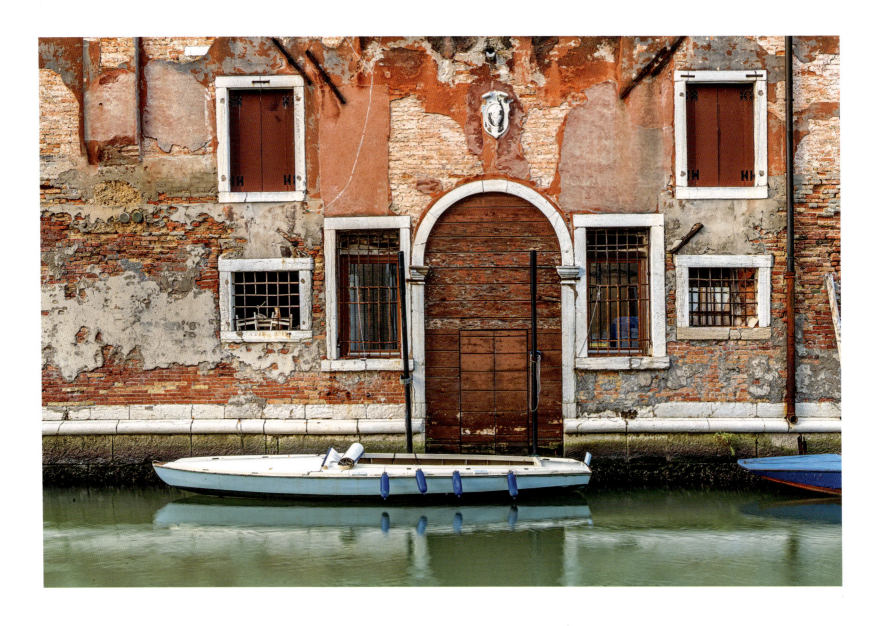

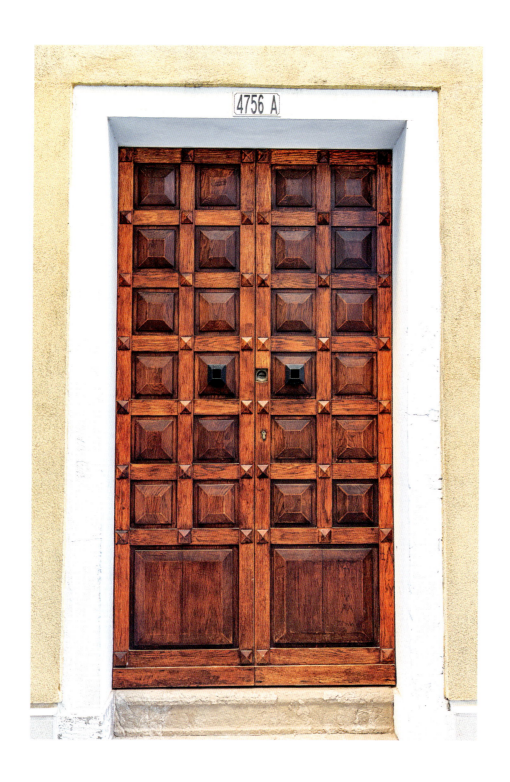

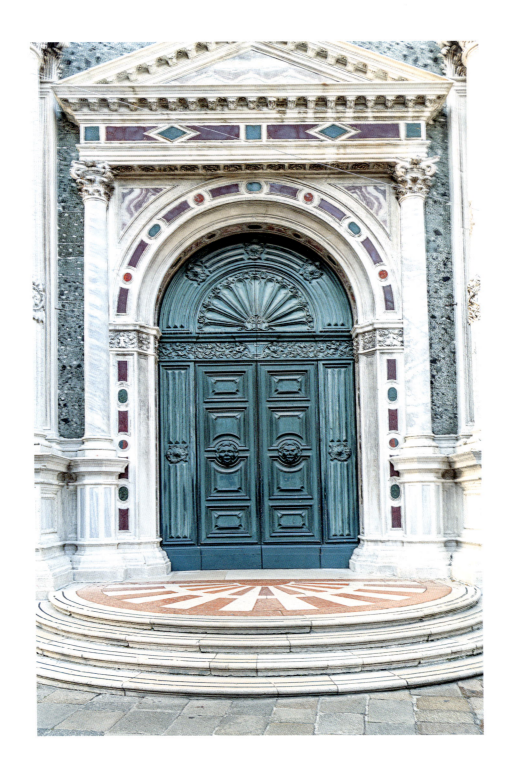

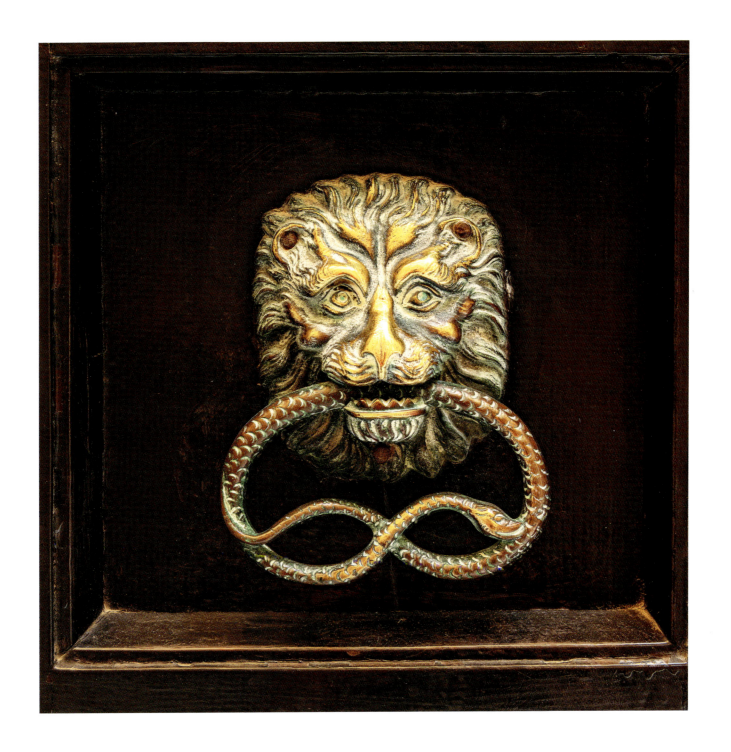

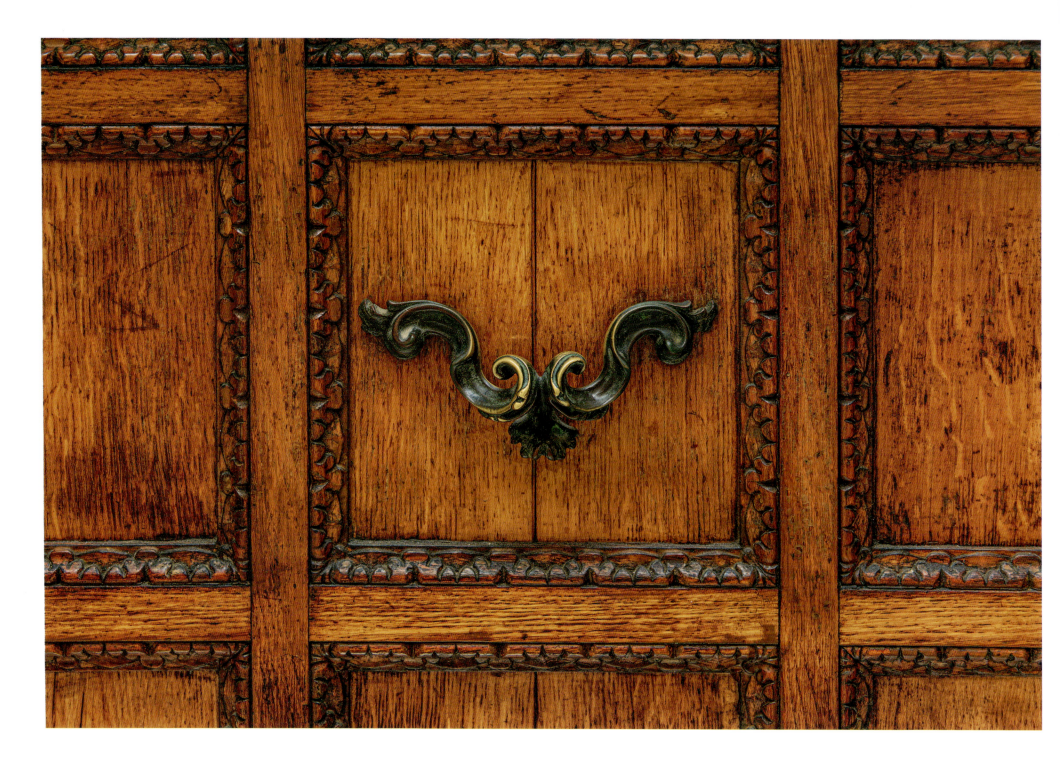

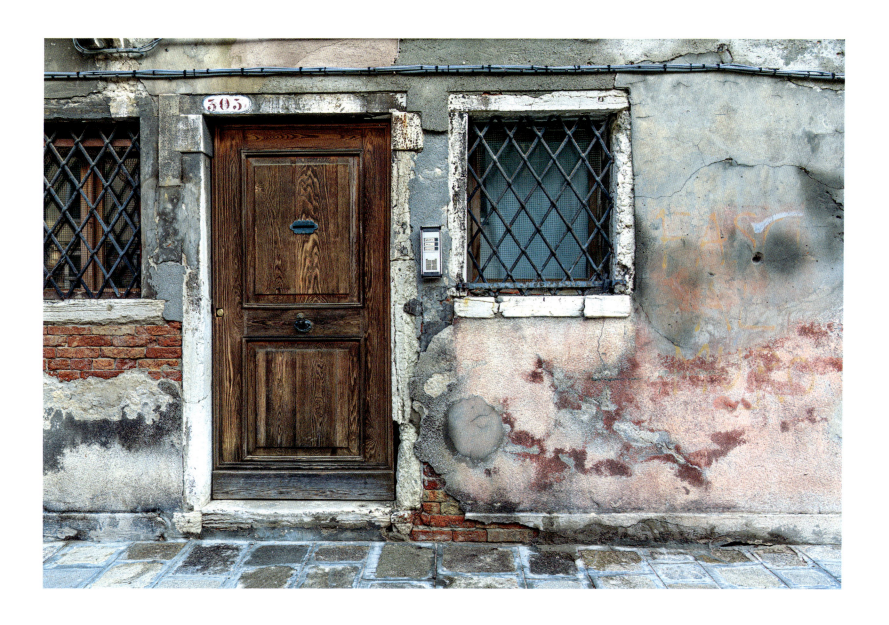

The patinas, colors, and details of Venetian doors are wondrous and fascinating.

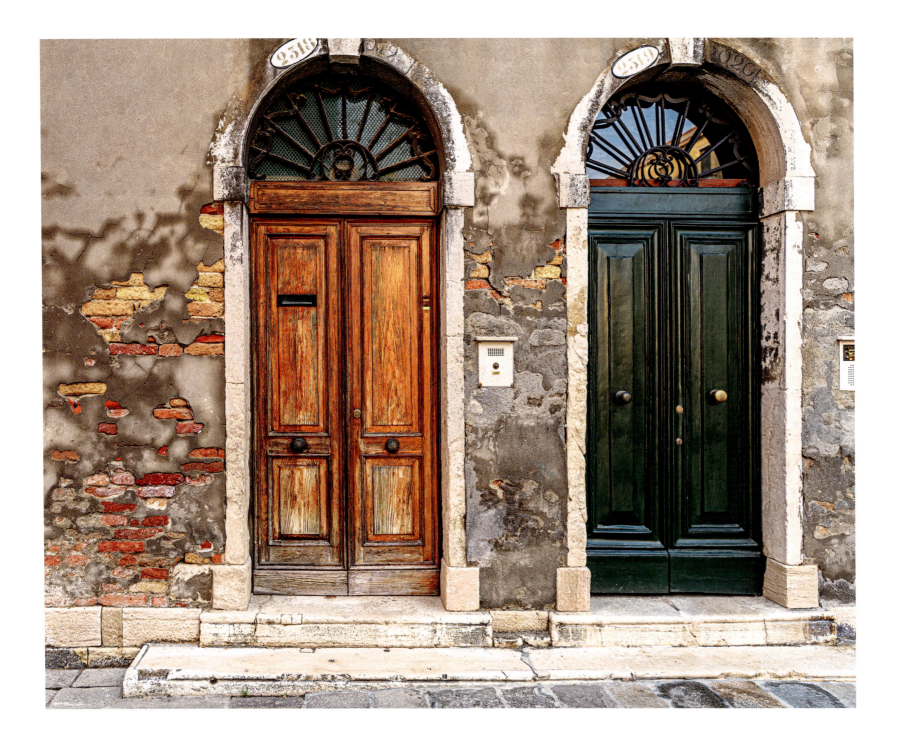

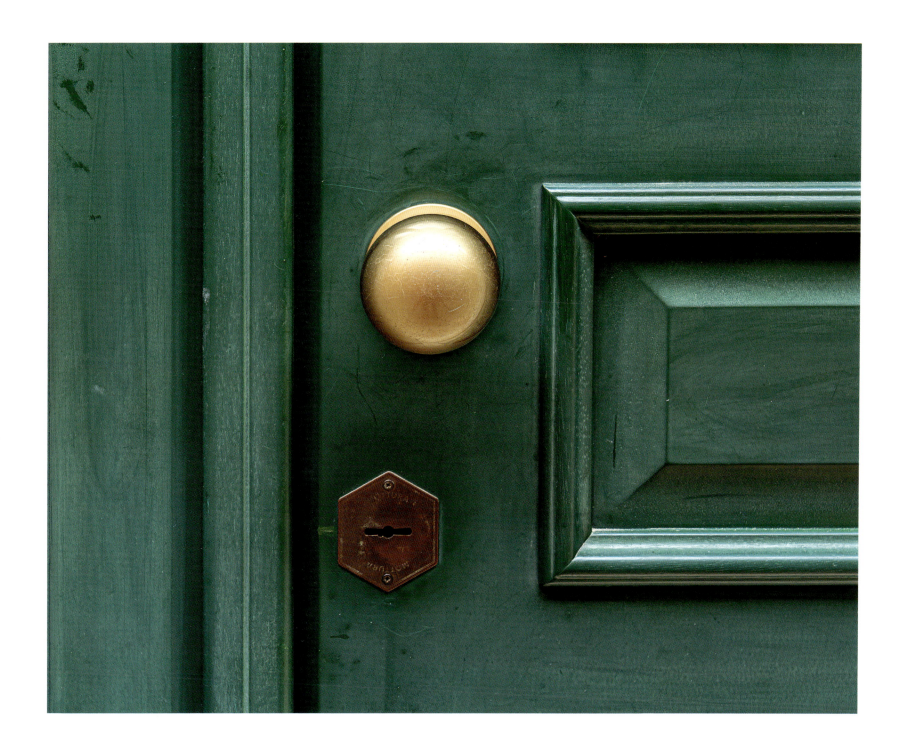

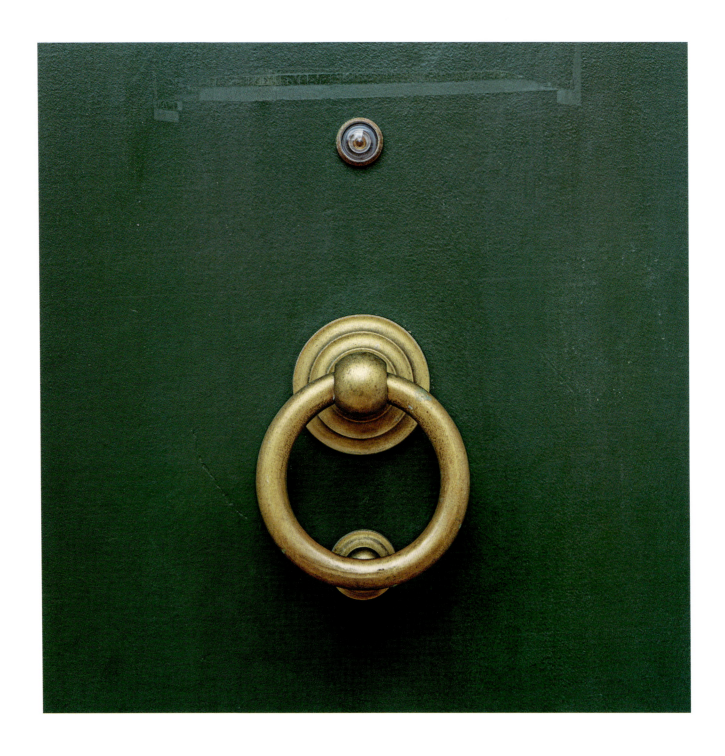

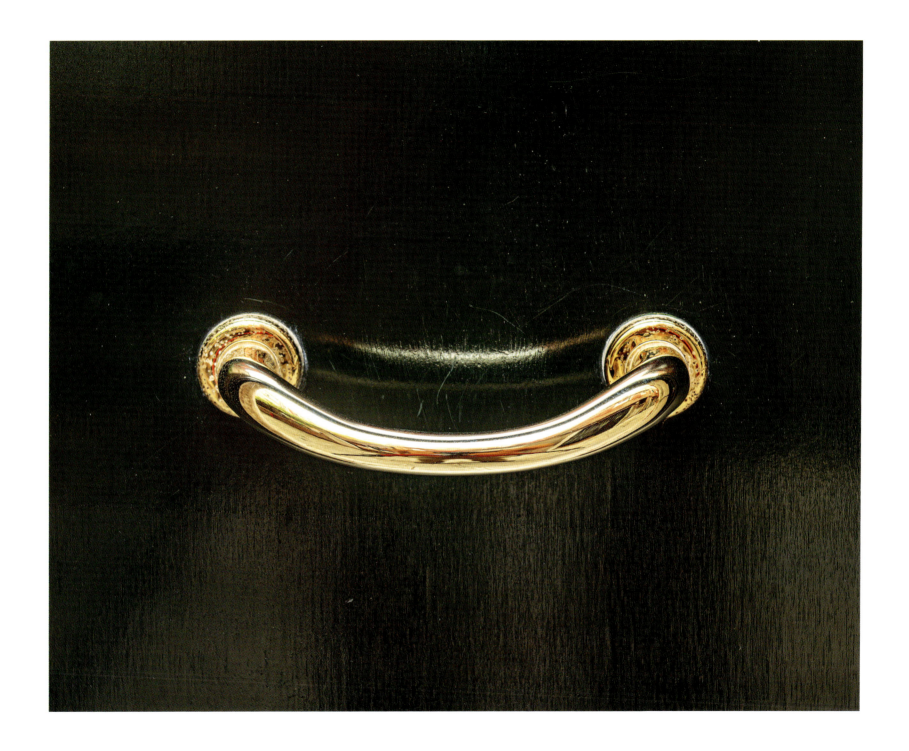

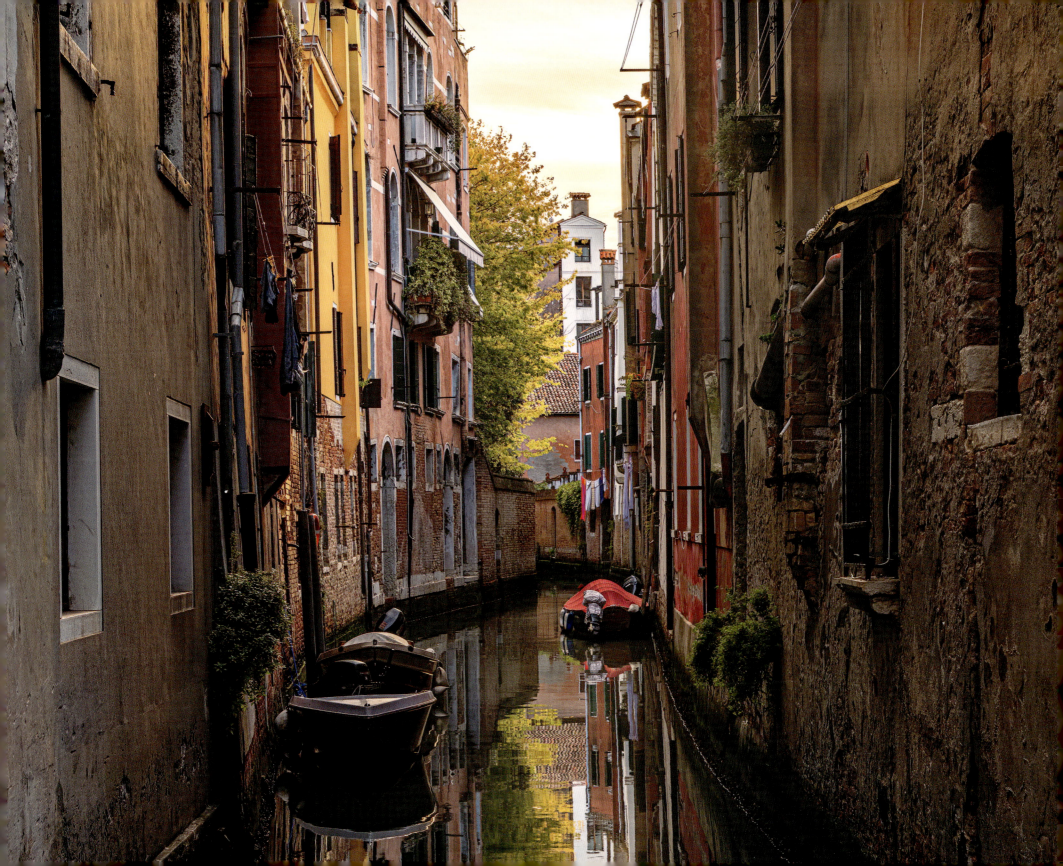

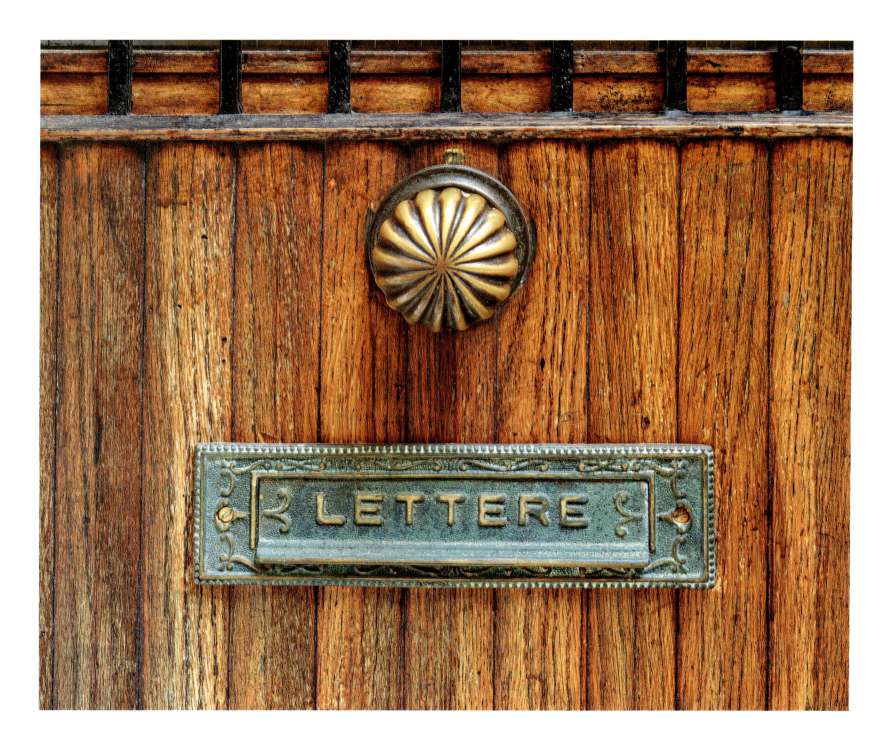

Opposite: San Polo

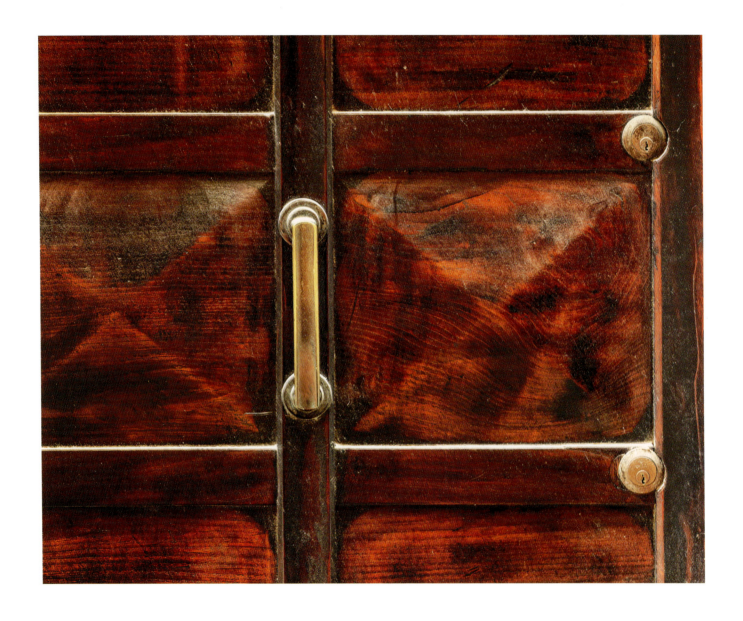

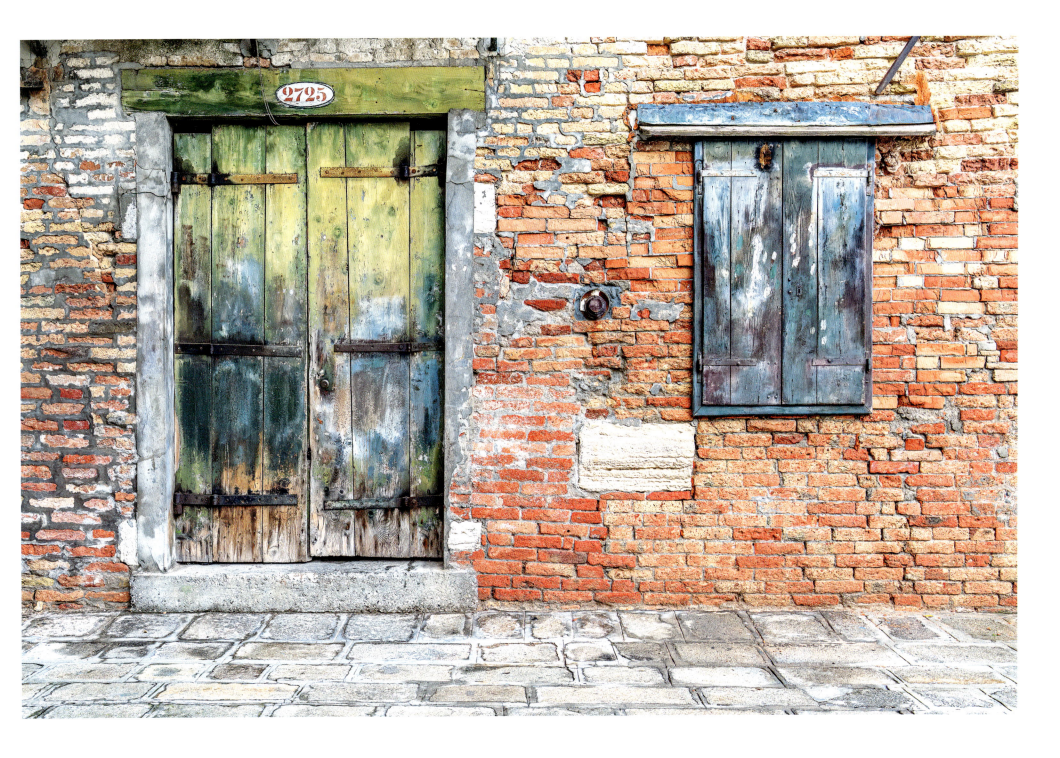

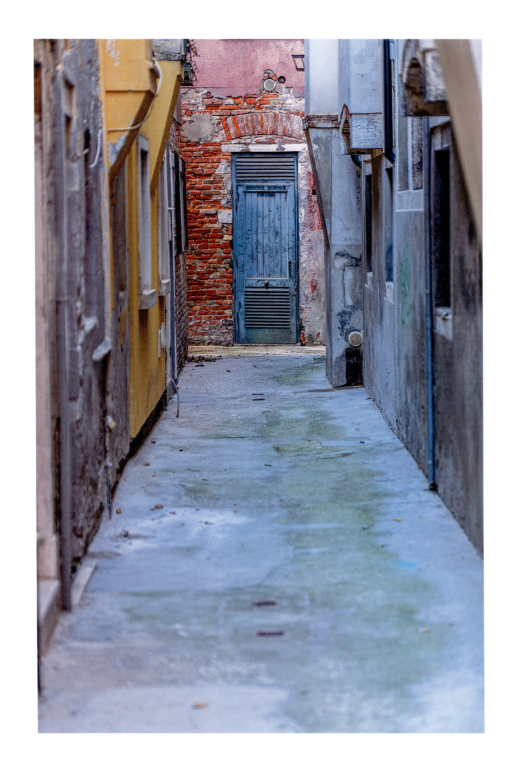

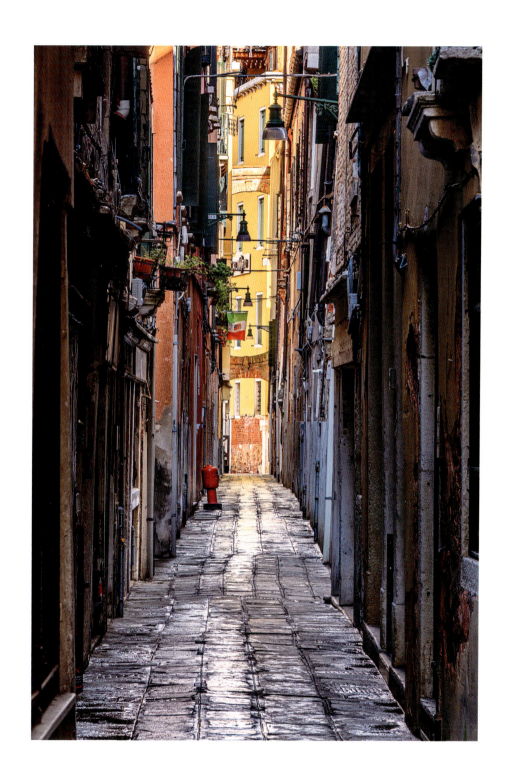

Narrow walkway in Cannaregio

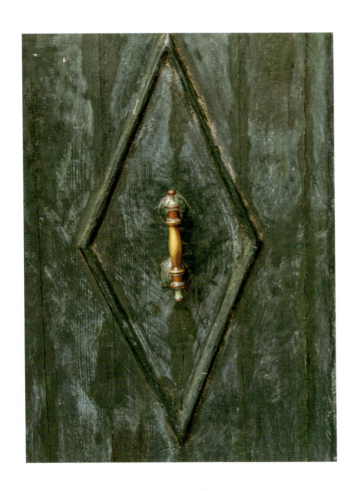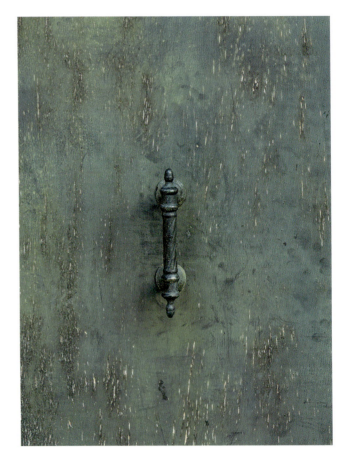

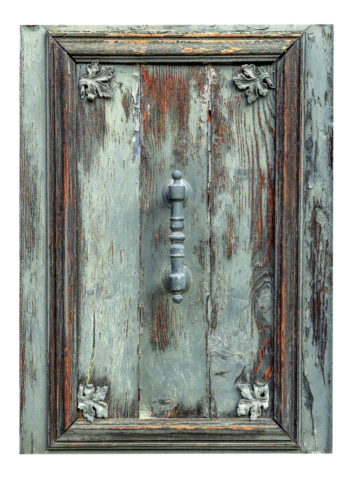
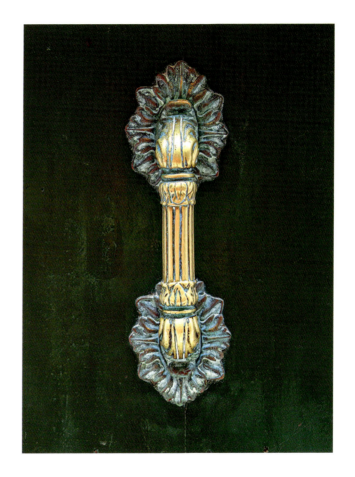

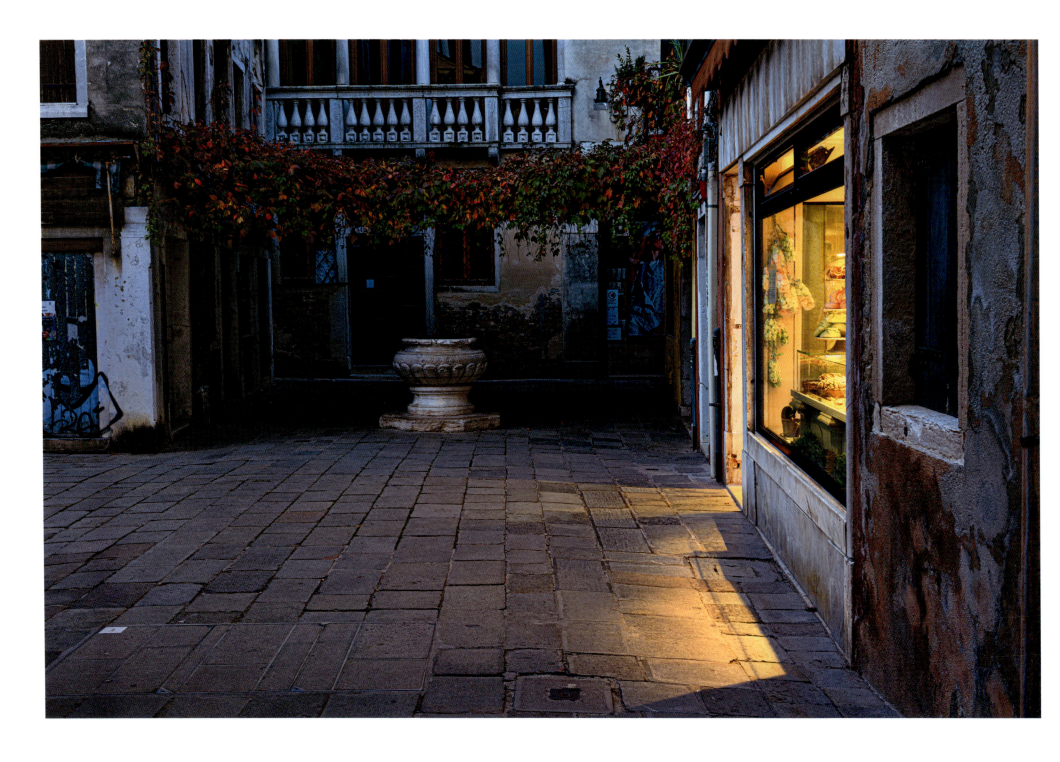

Calle del Fumo, Cannaregio

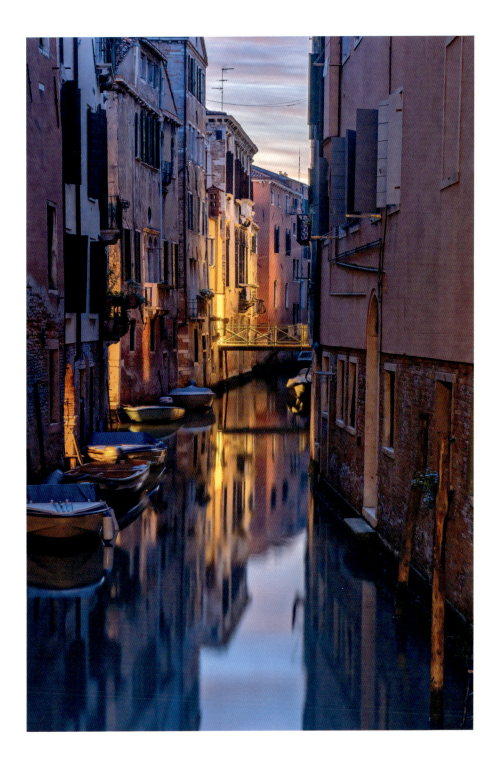

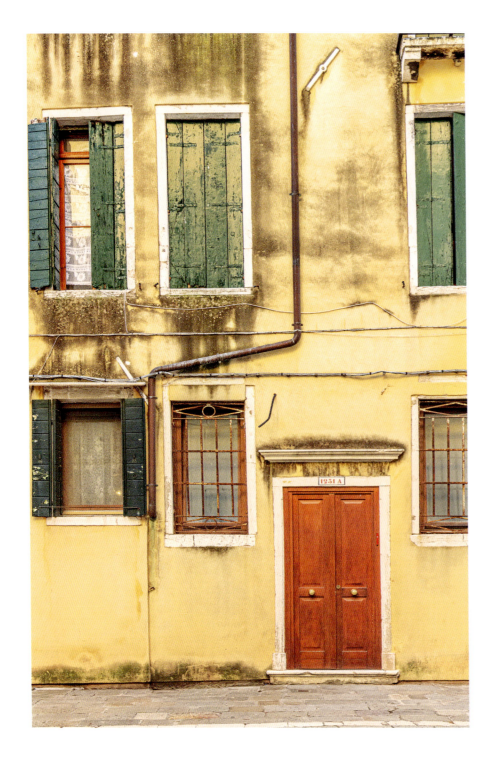
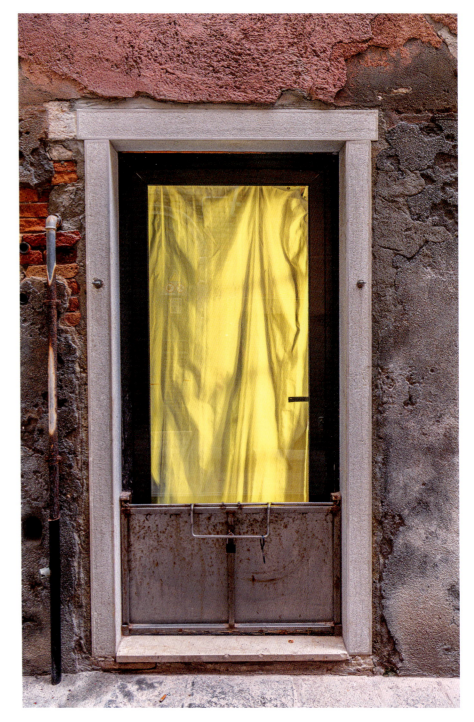

30 *Right:* A metal flood barrier on a door

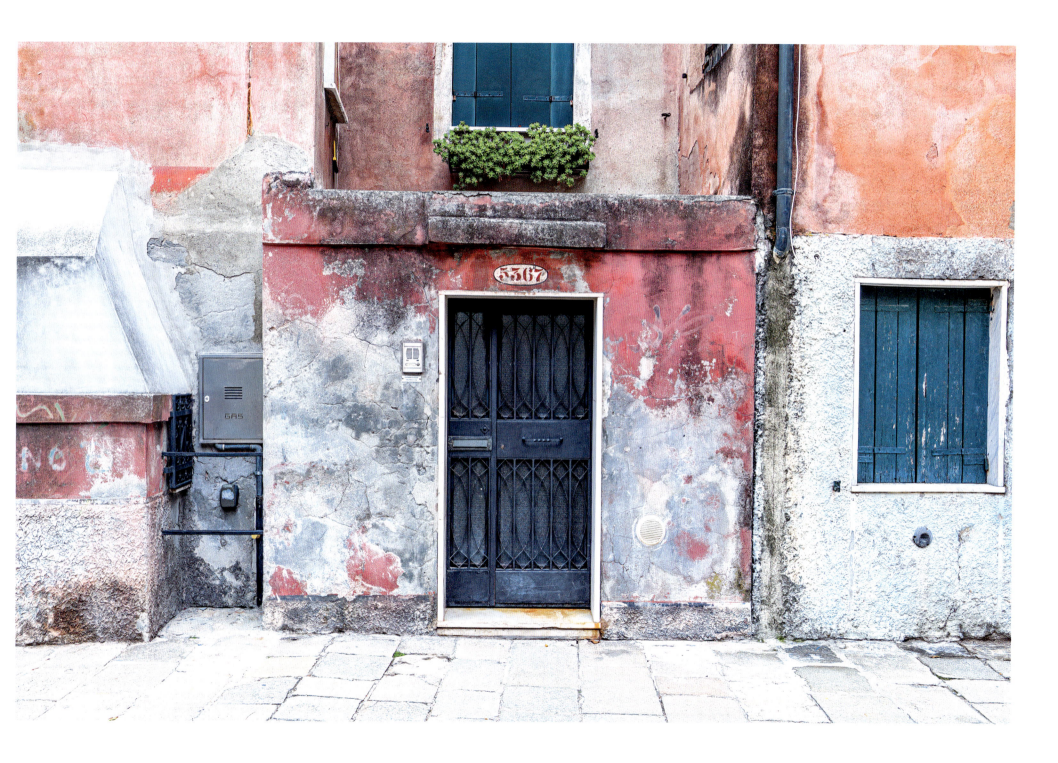

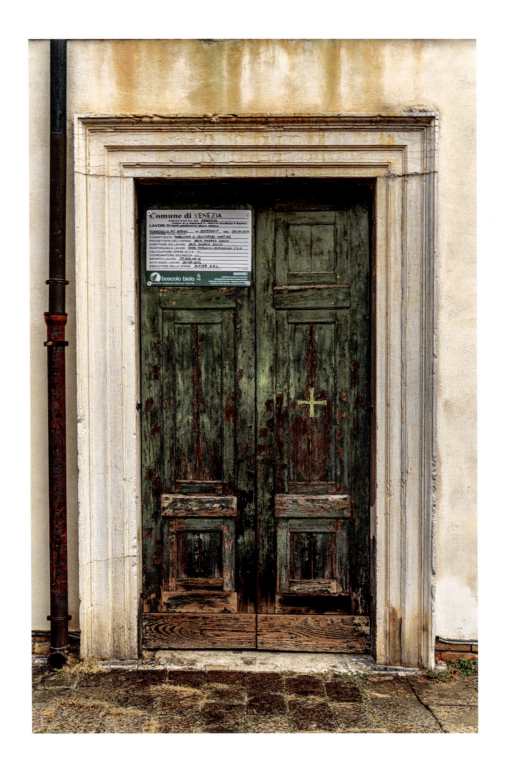

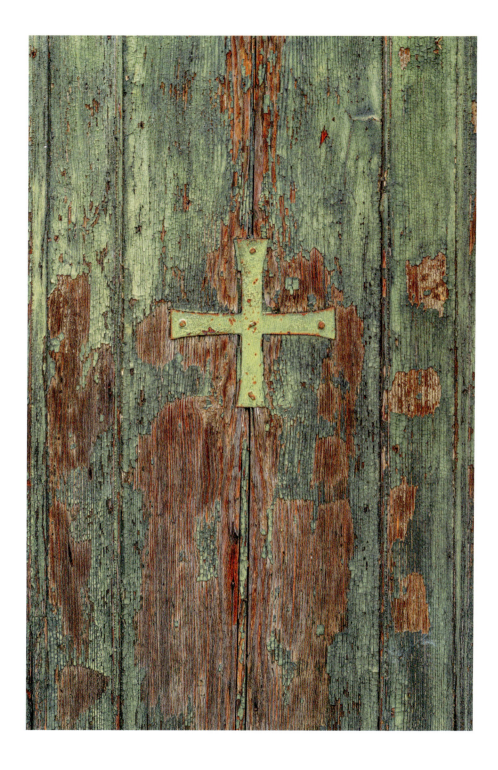

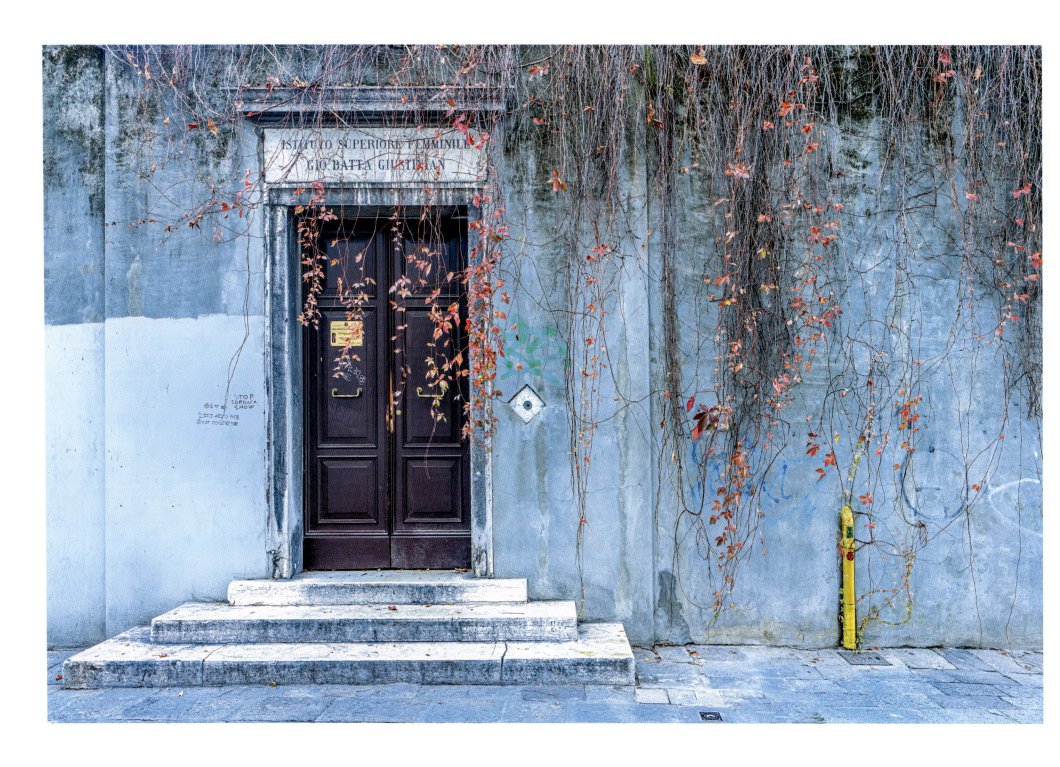

Calle della Carità, Dorsoduro

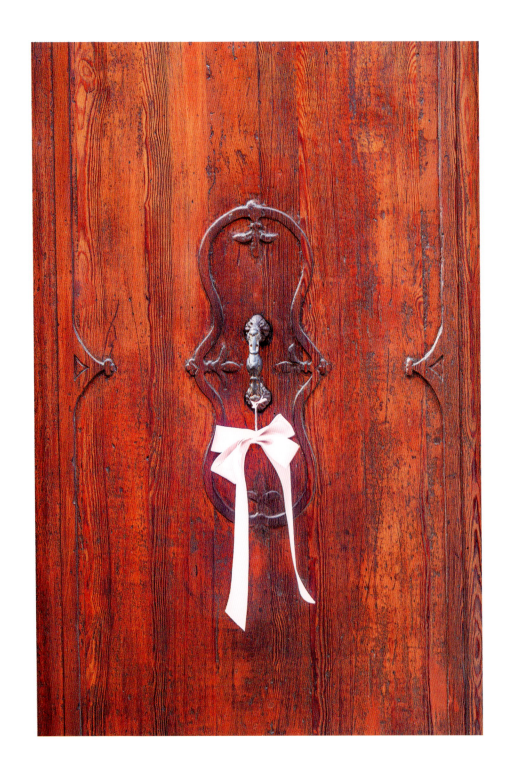

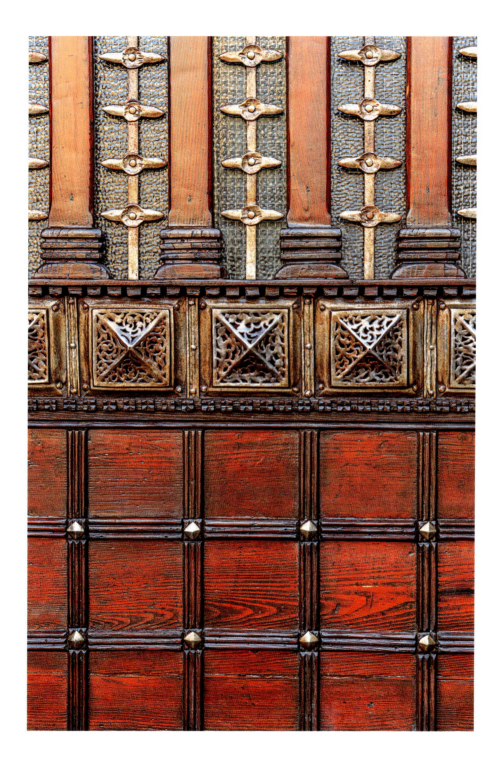

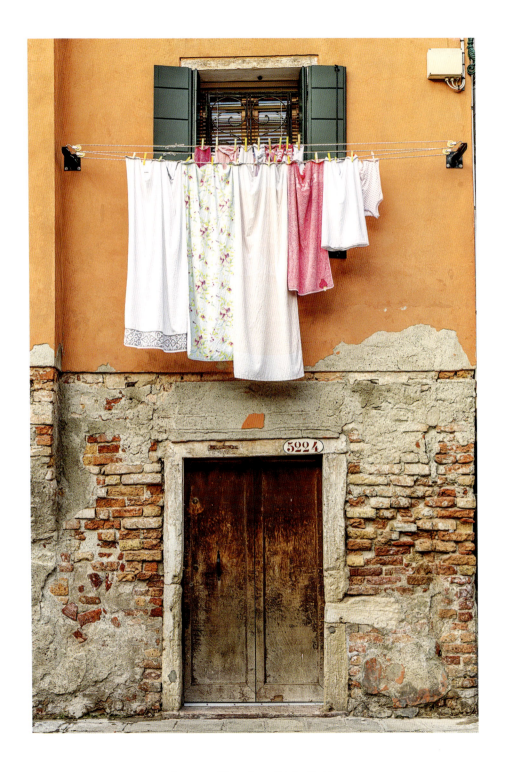

Opposite: View from Rialto Bridge

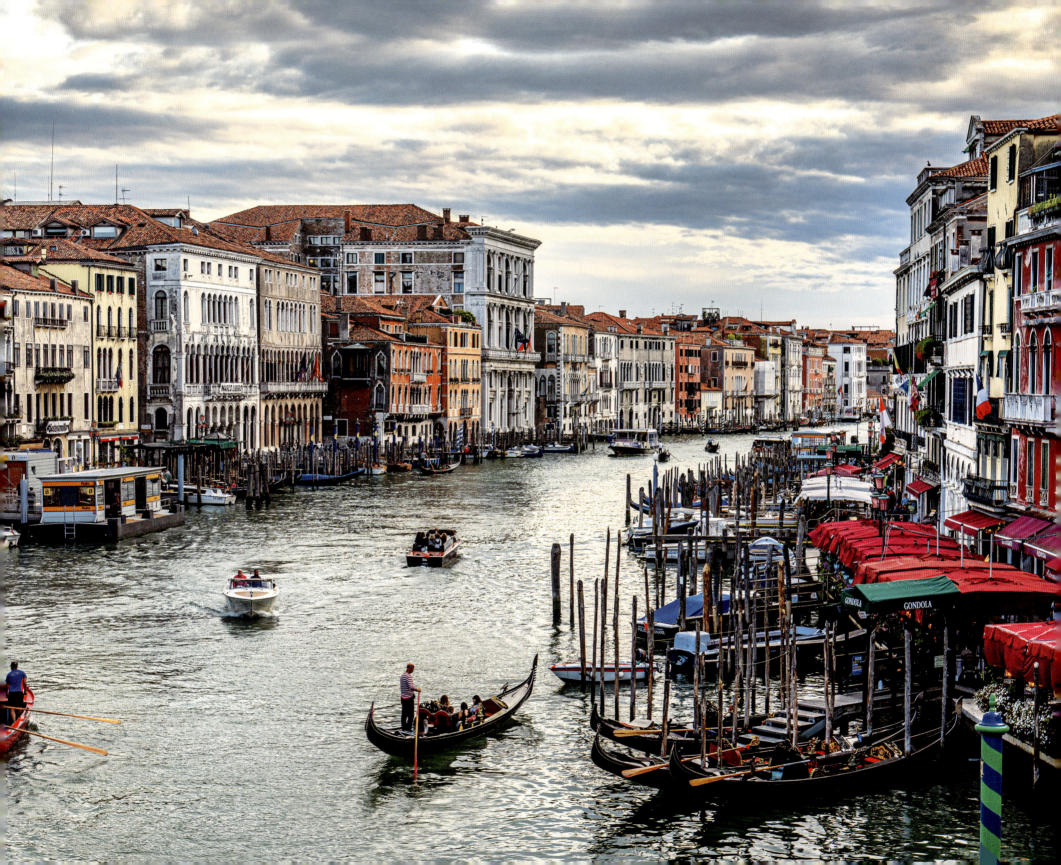

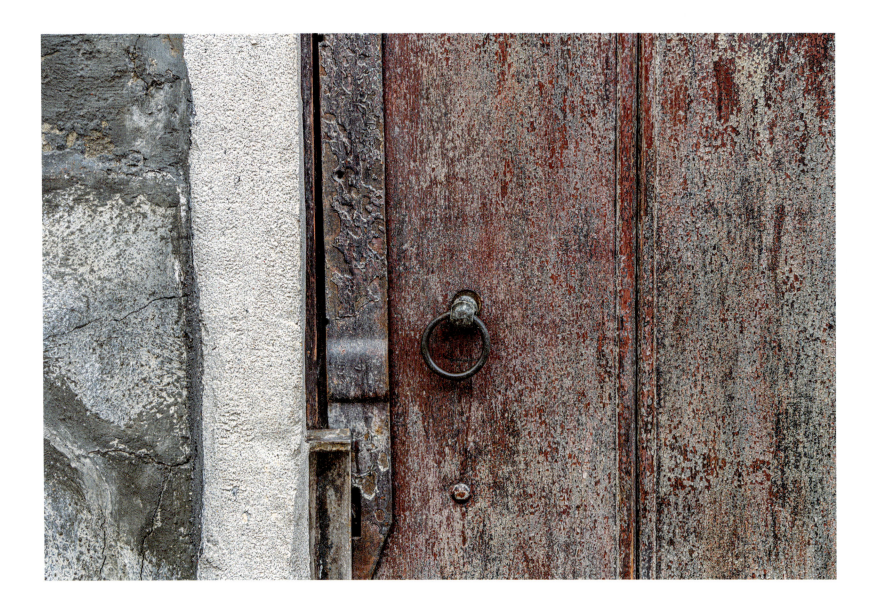

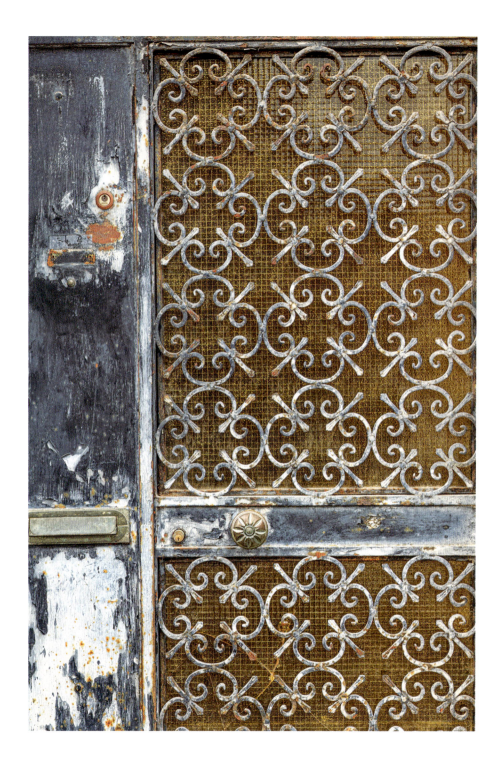

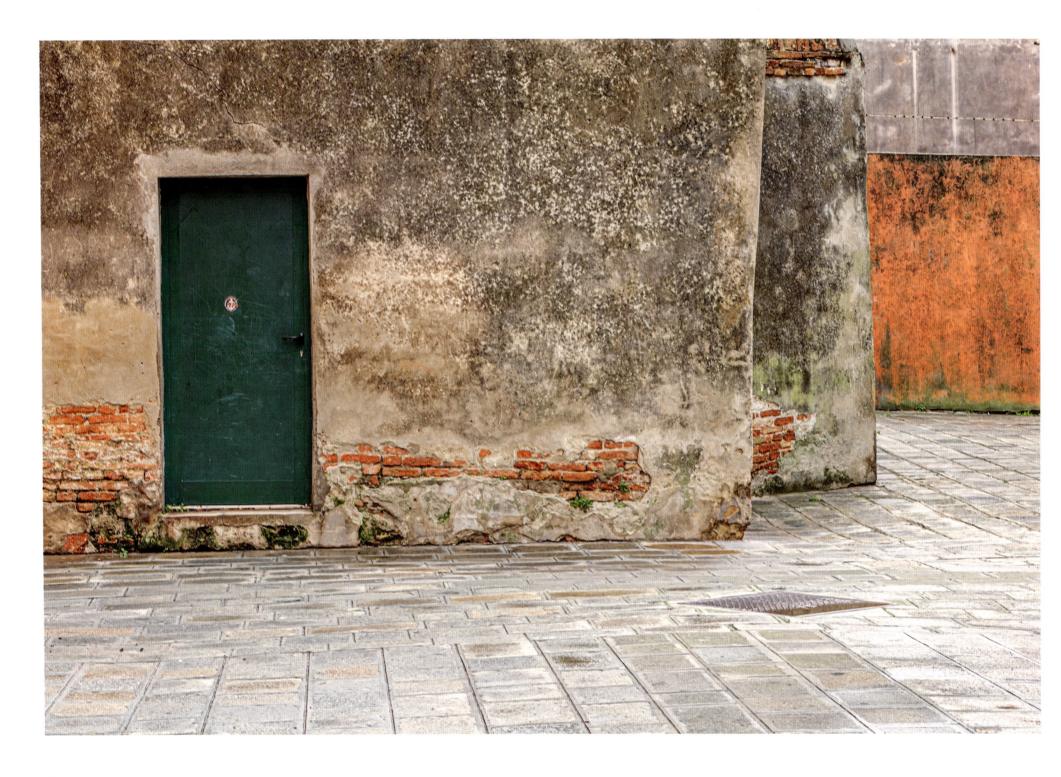

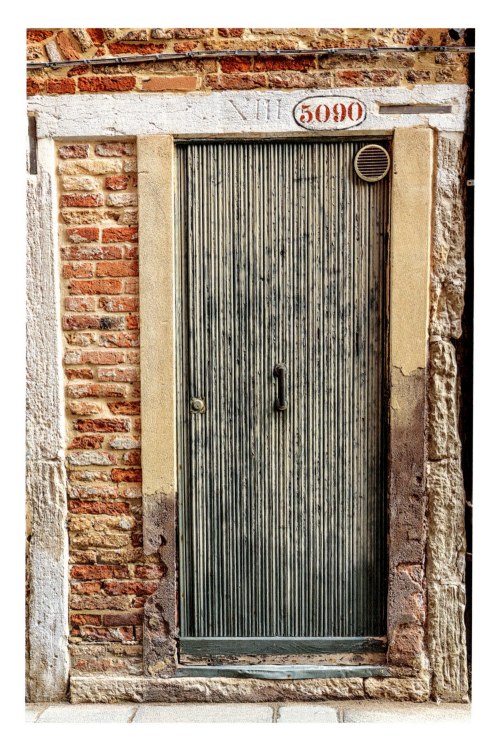

During the times of the Venetian Republic, Roman numerals were chiseled into the door frame to identify a specific rental unit of a landlord, Castello.

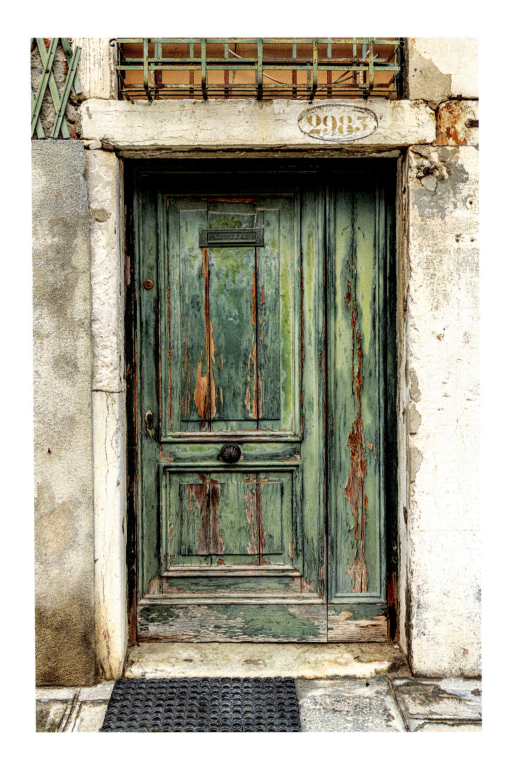

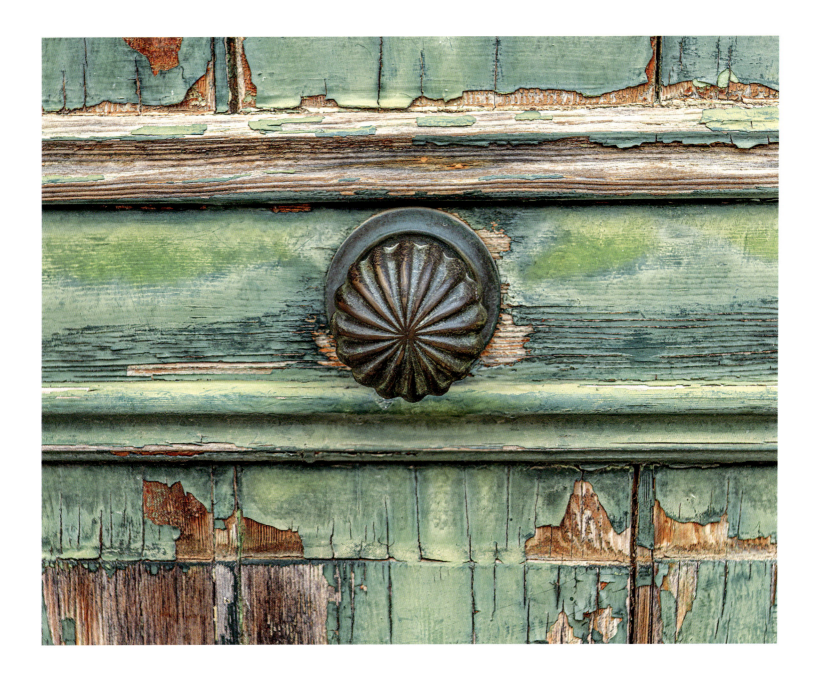

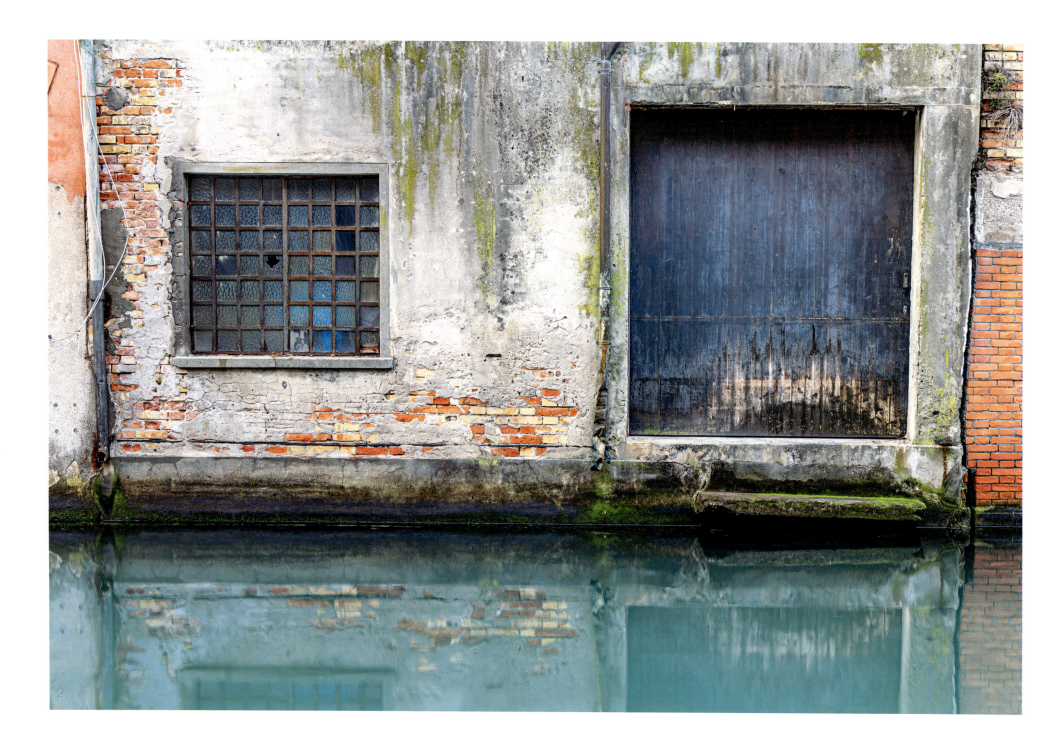

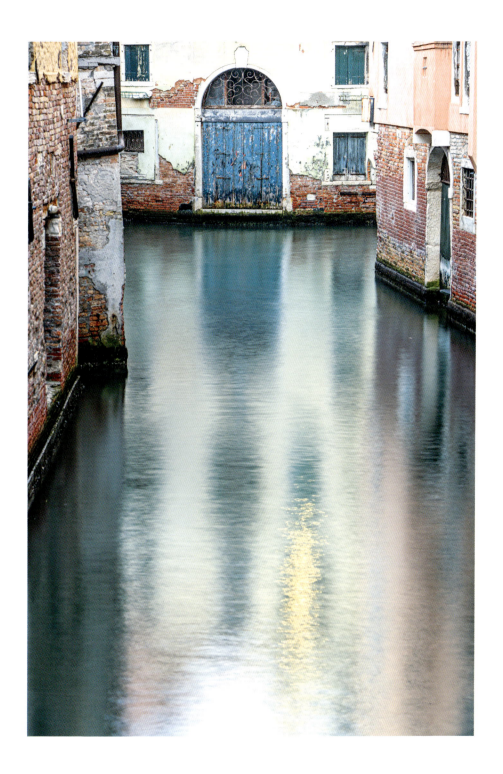

Rio de San Lio, near Corte Seconda del Milion, the home of Marco Polo

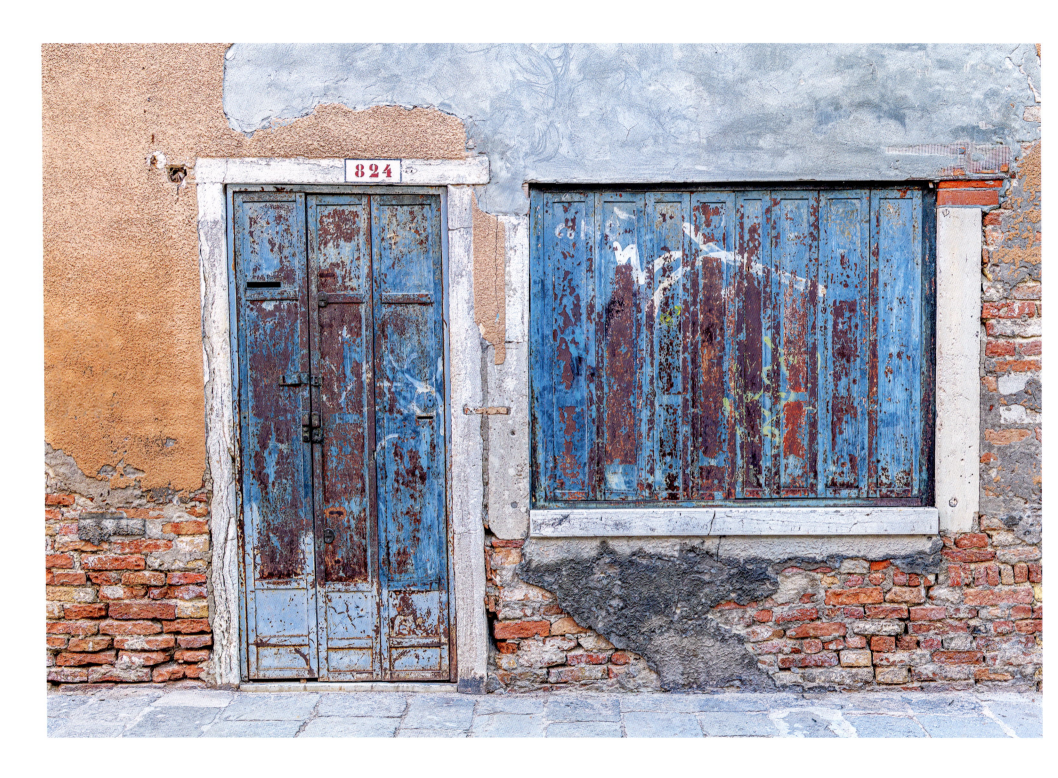

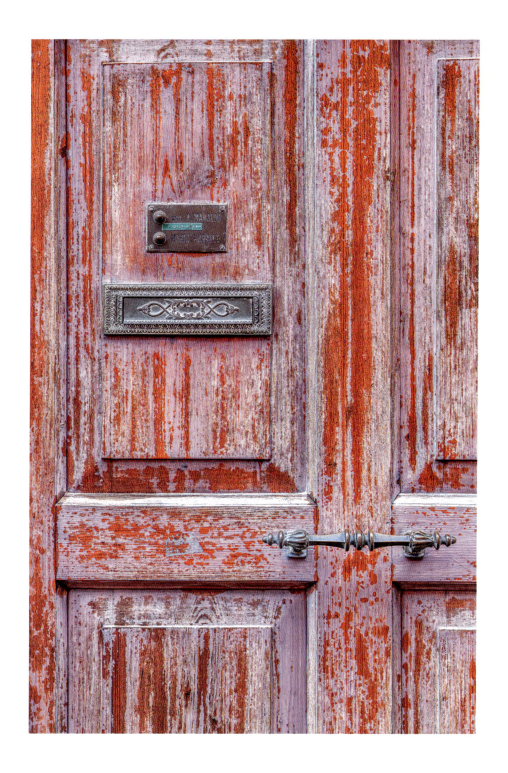

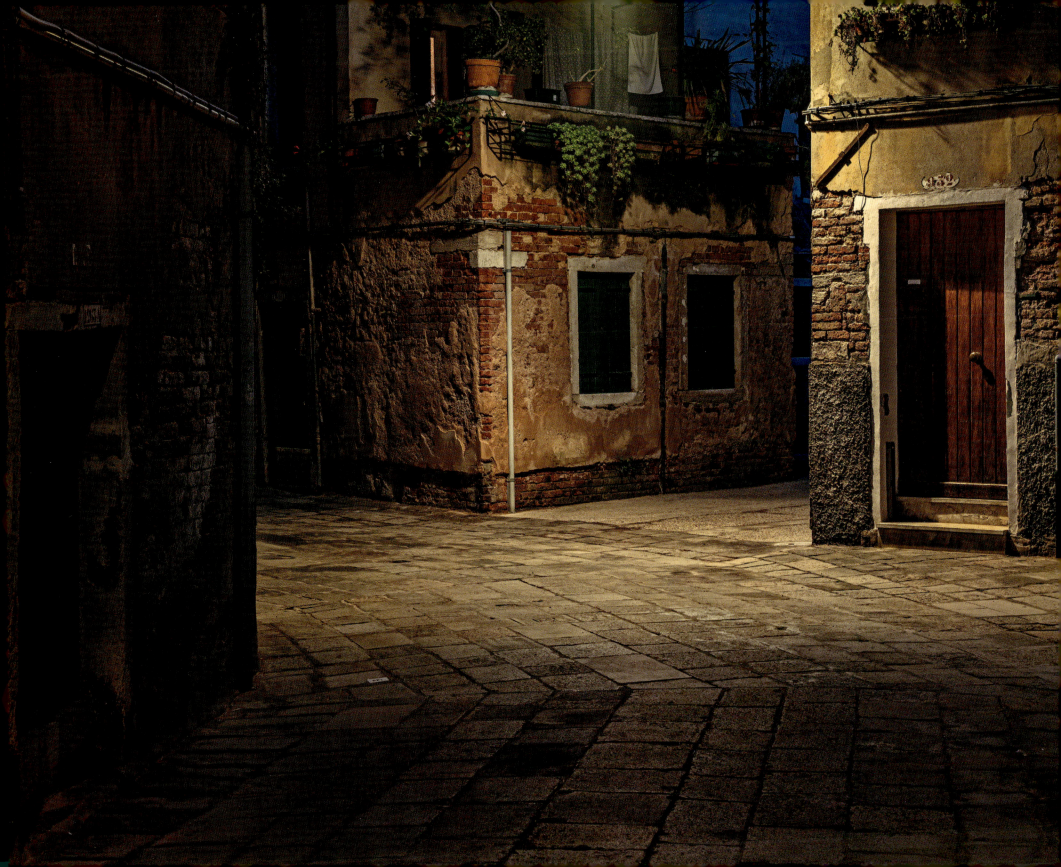

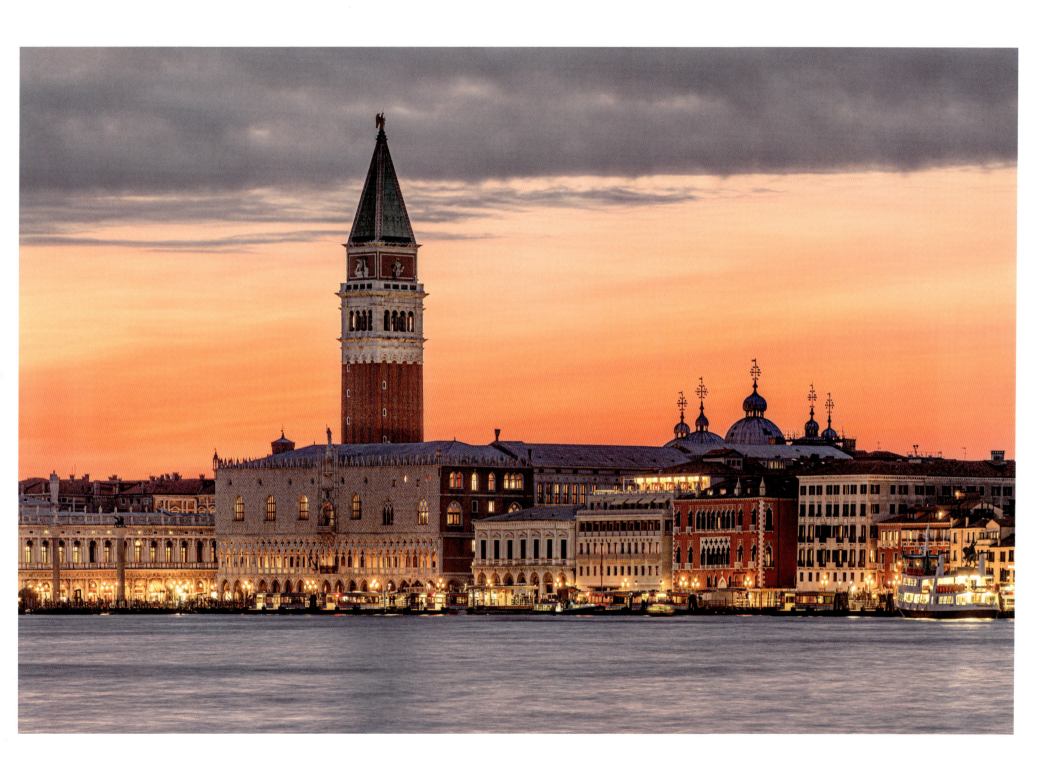

Doge's Palace and the bell tower of Saint Mark's Basilica from San Giorgio Maggiore

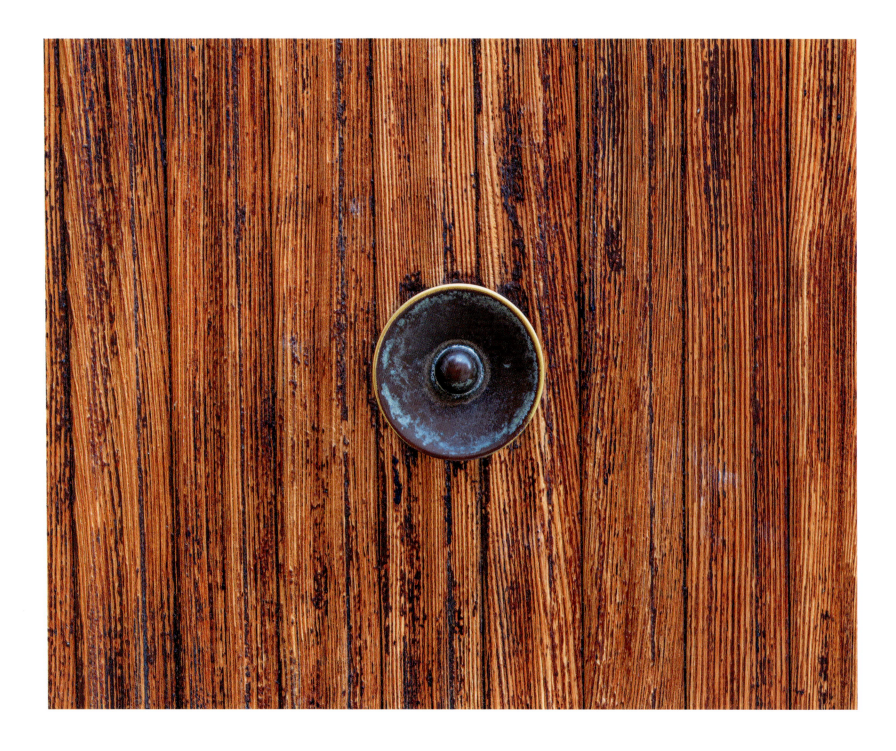

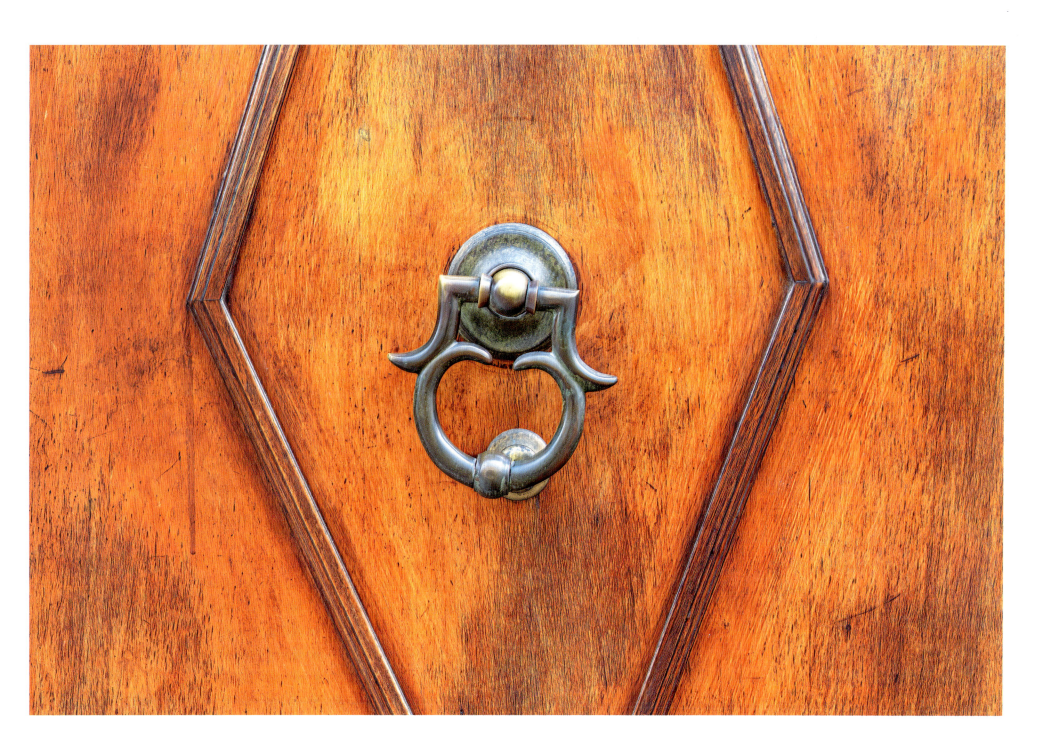

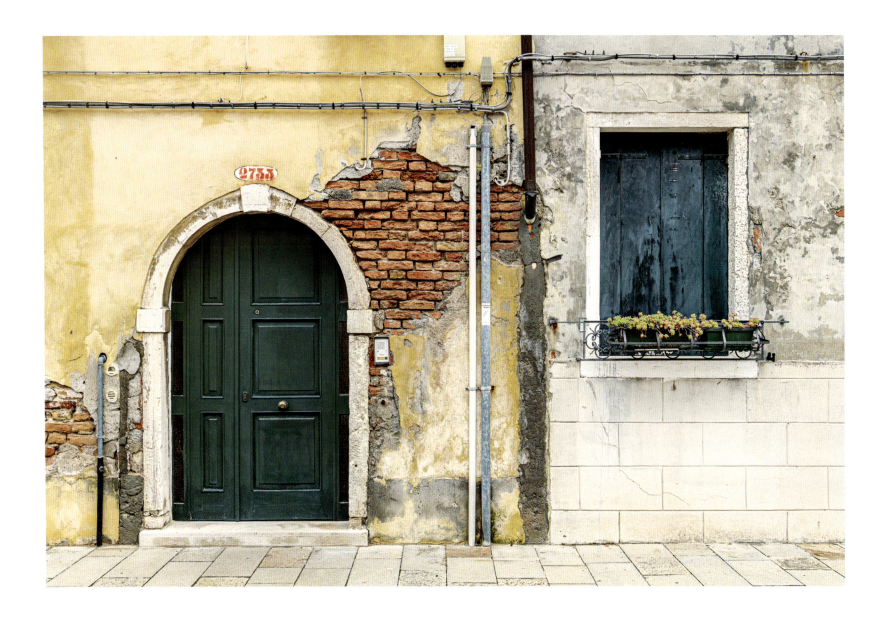

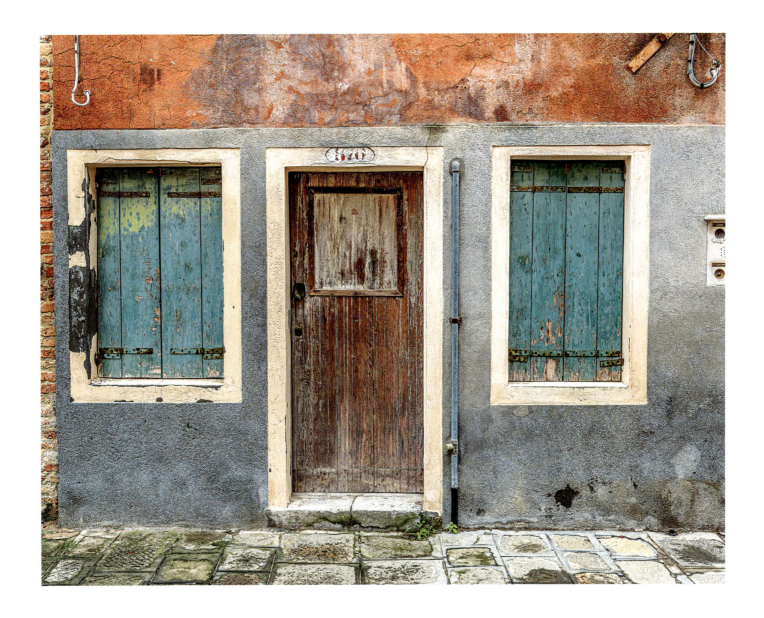

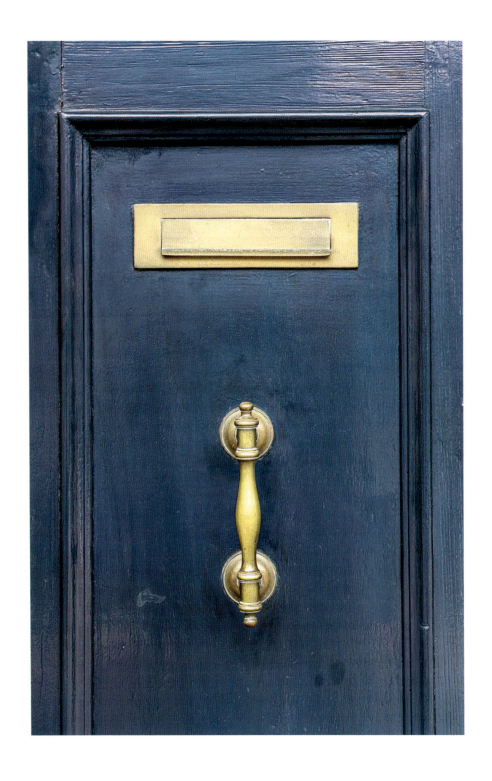

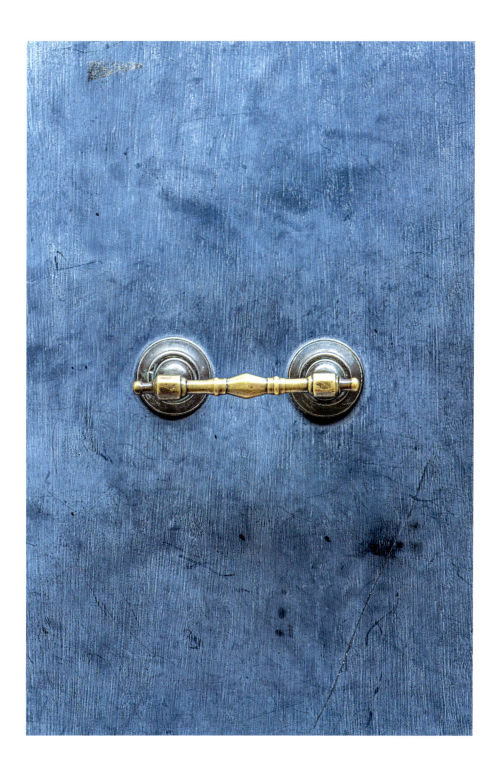

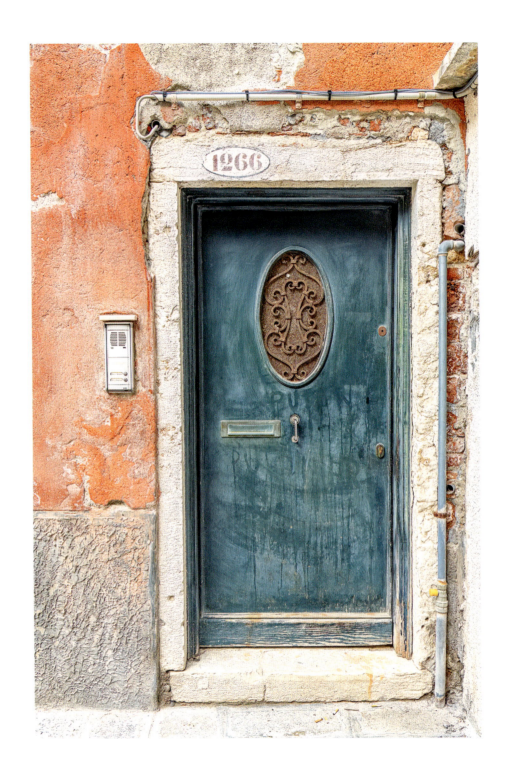

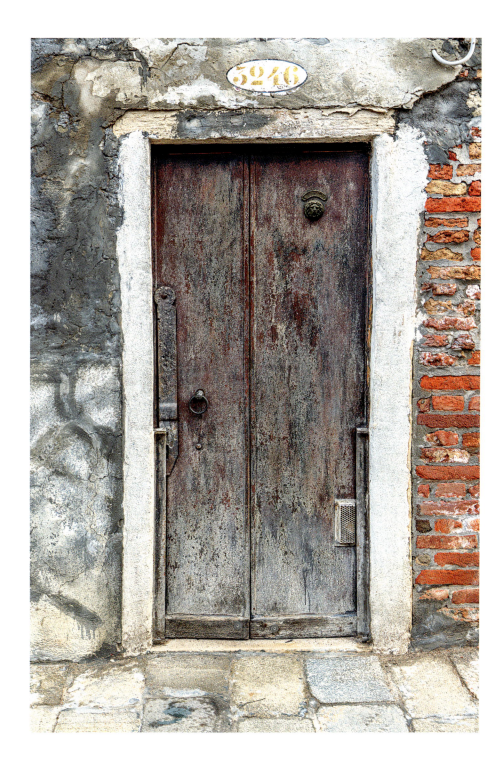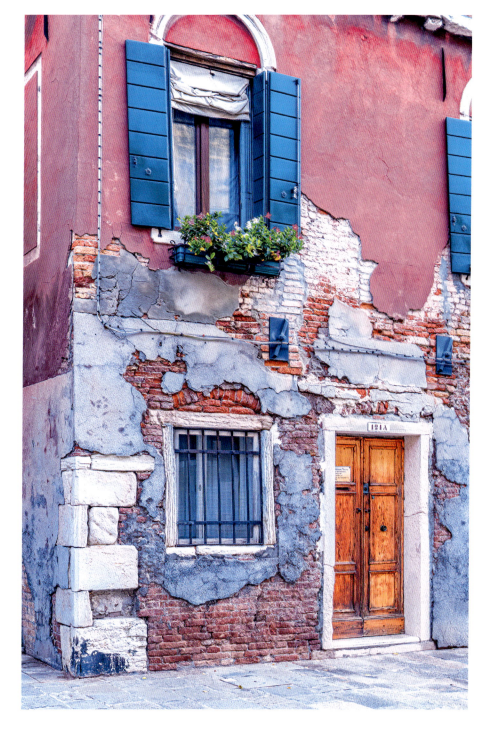

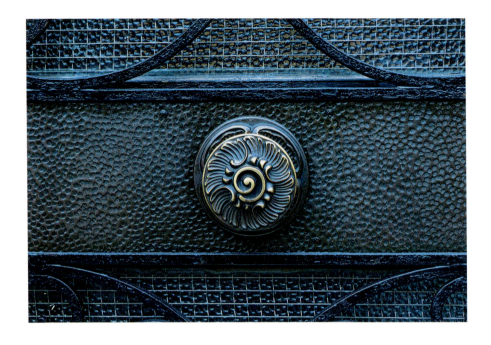
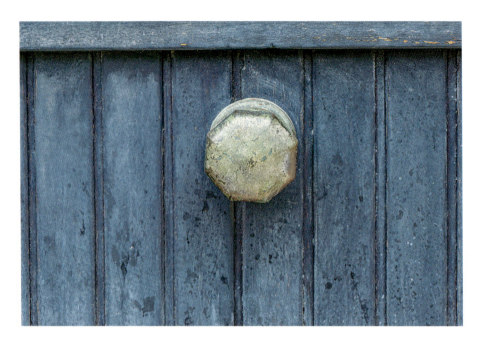
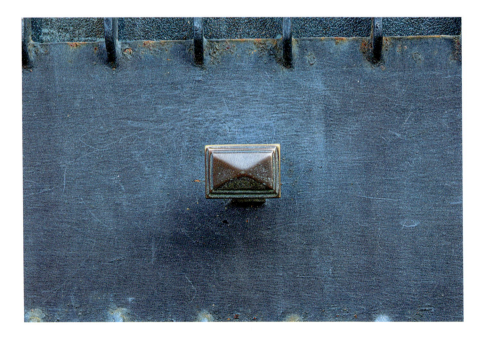
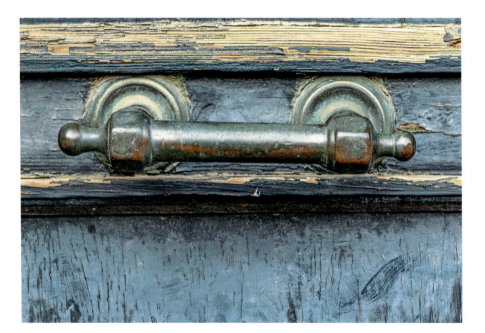

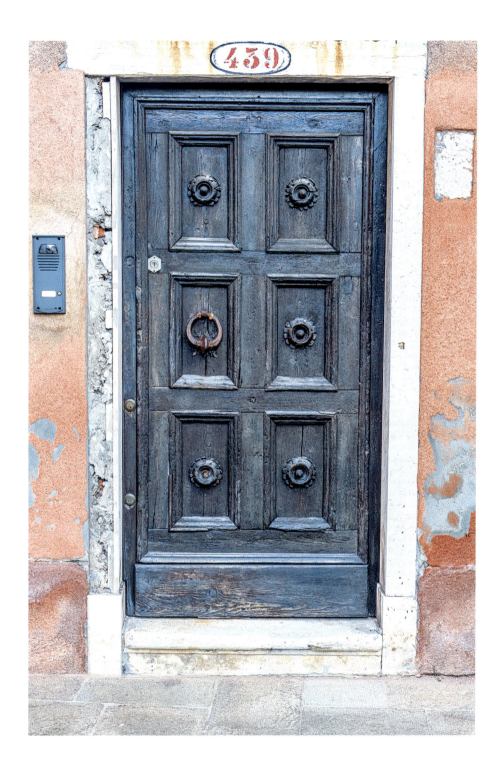

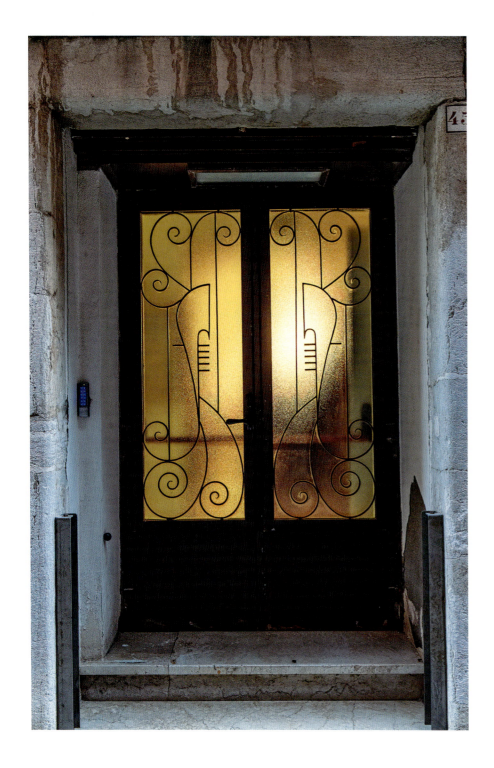
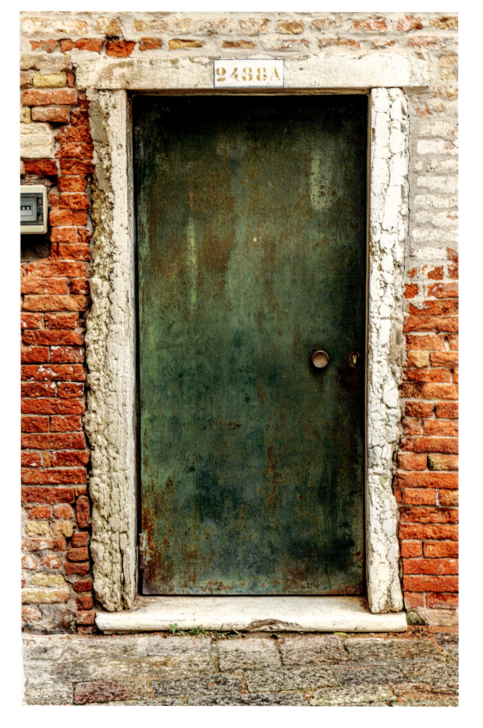

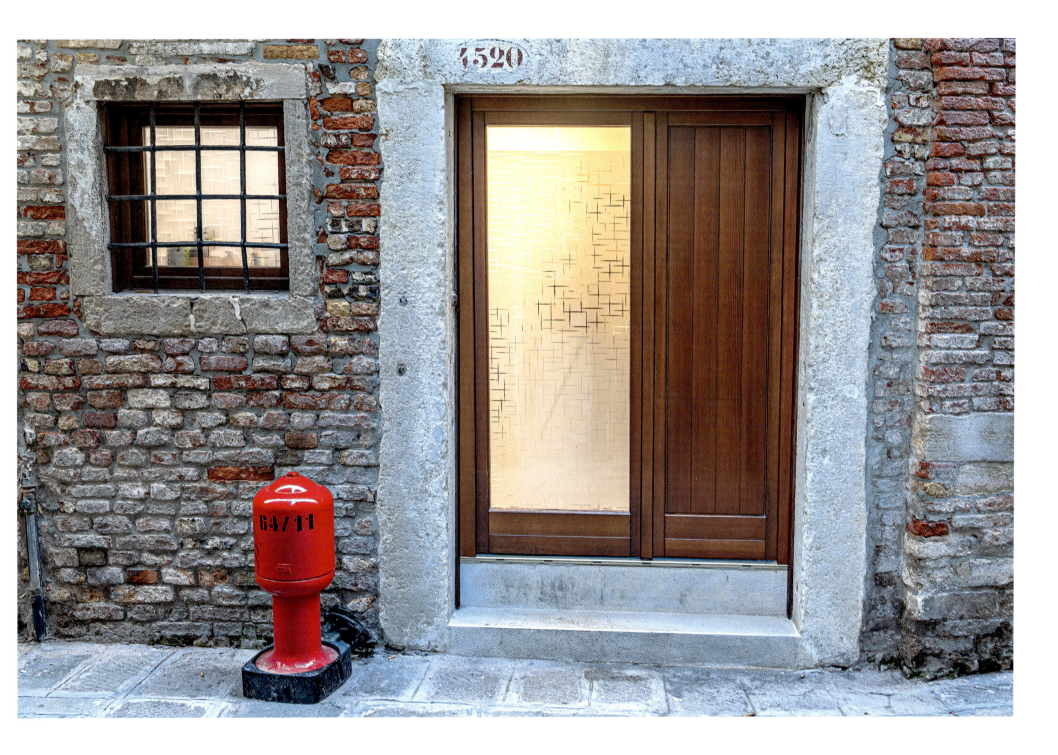

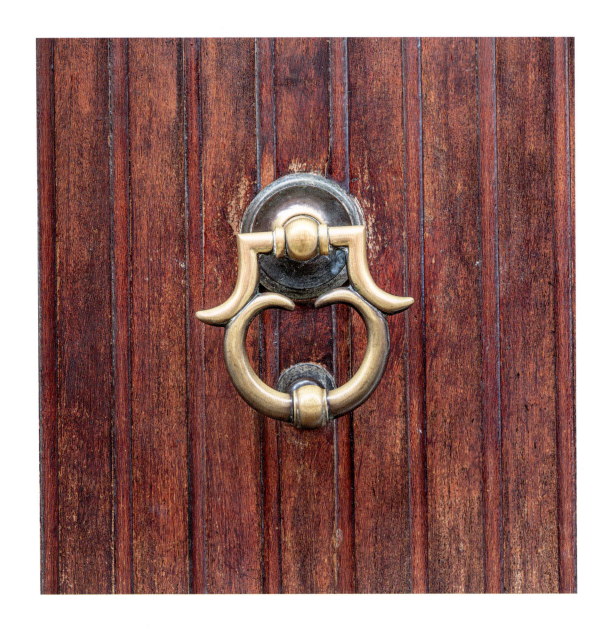

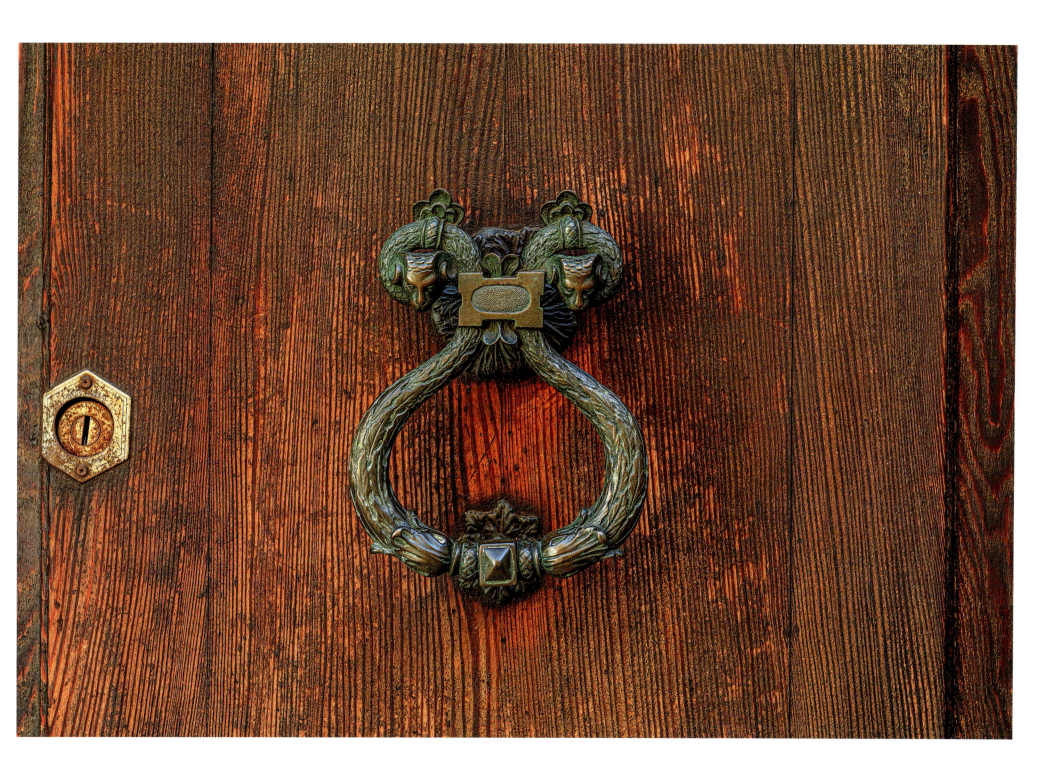

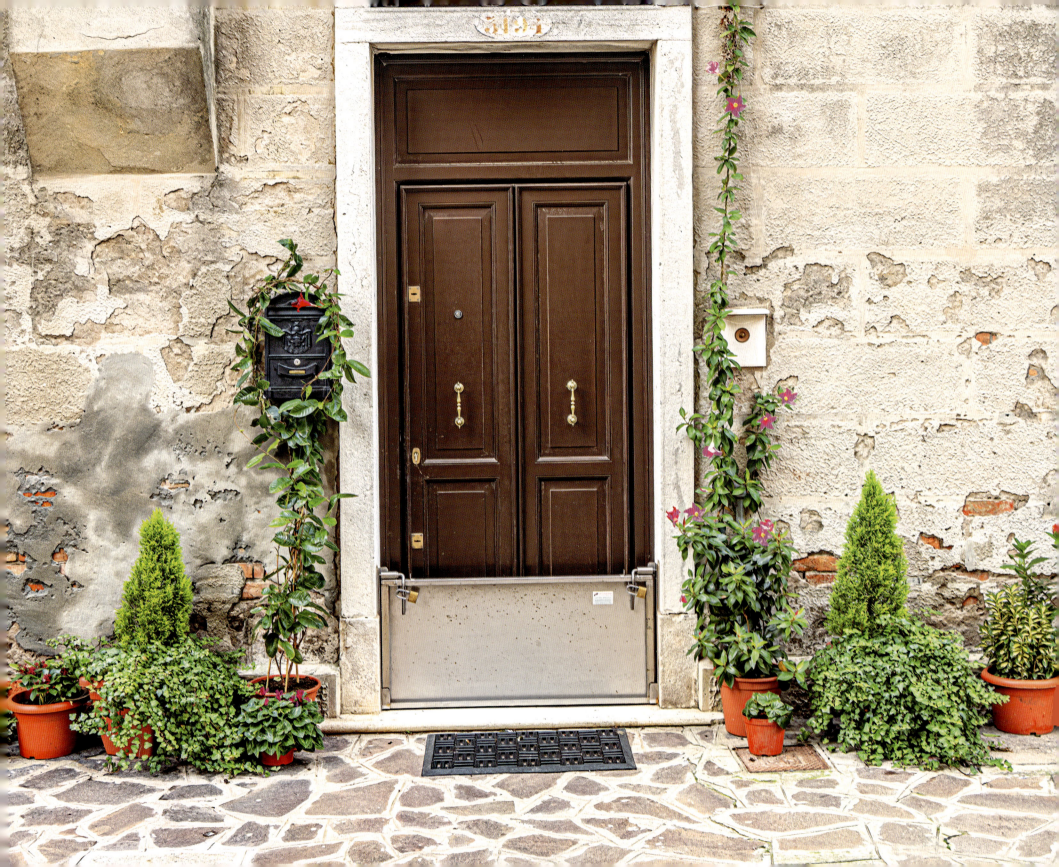

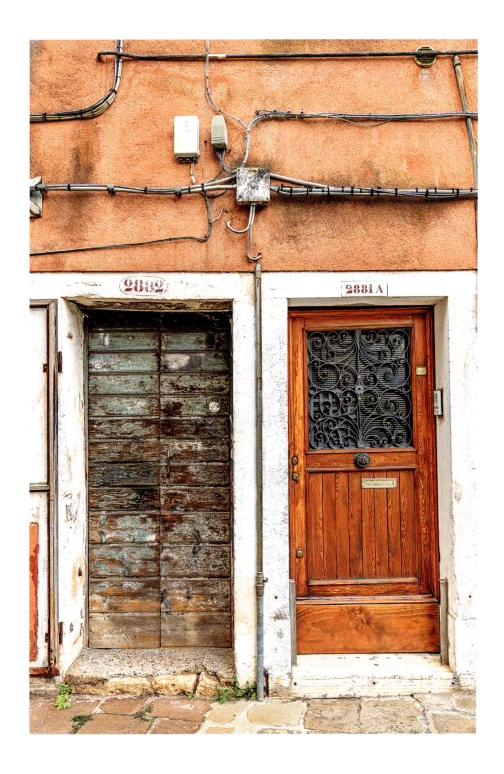

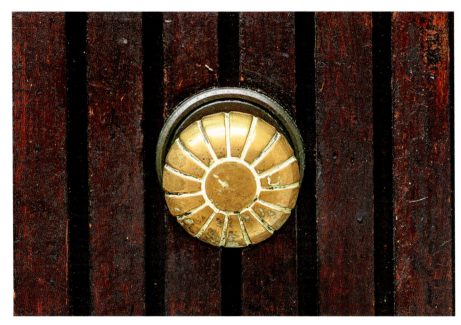
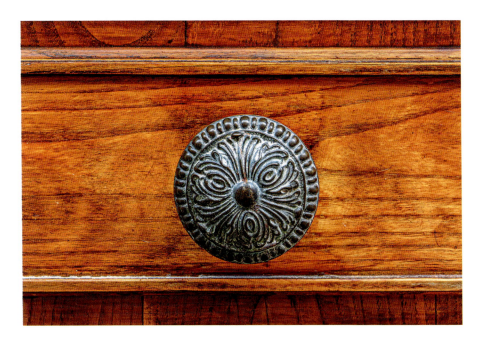
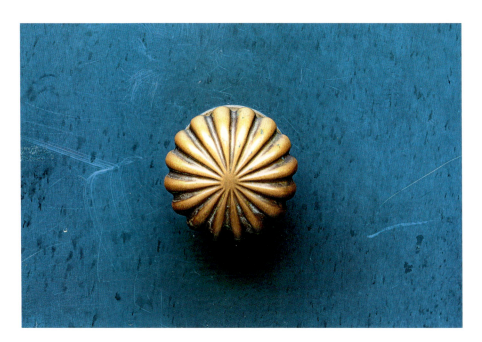

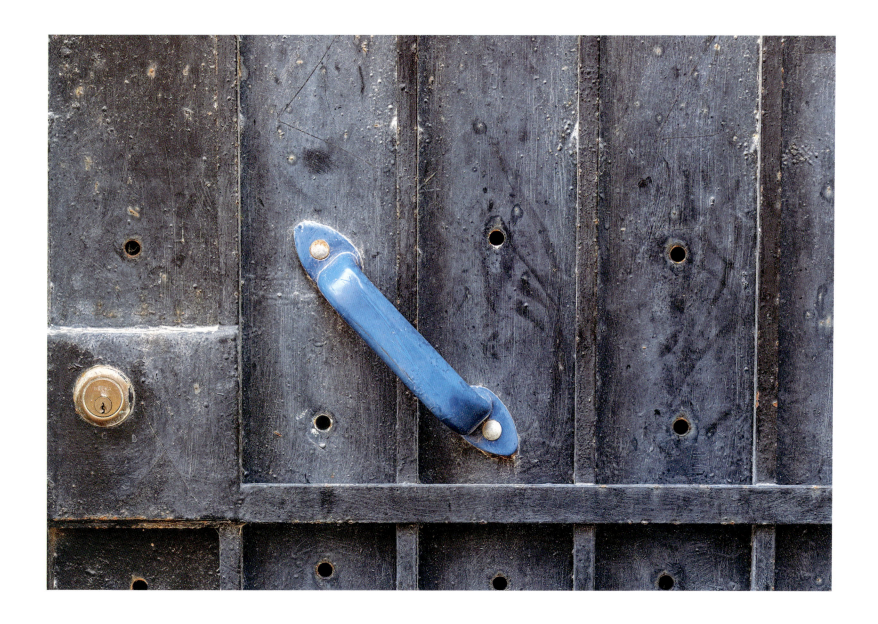

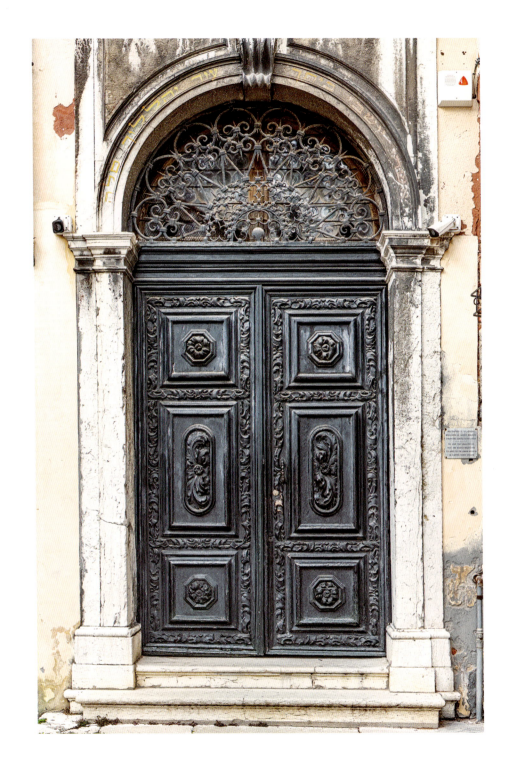

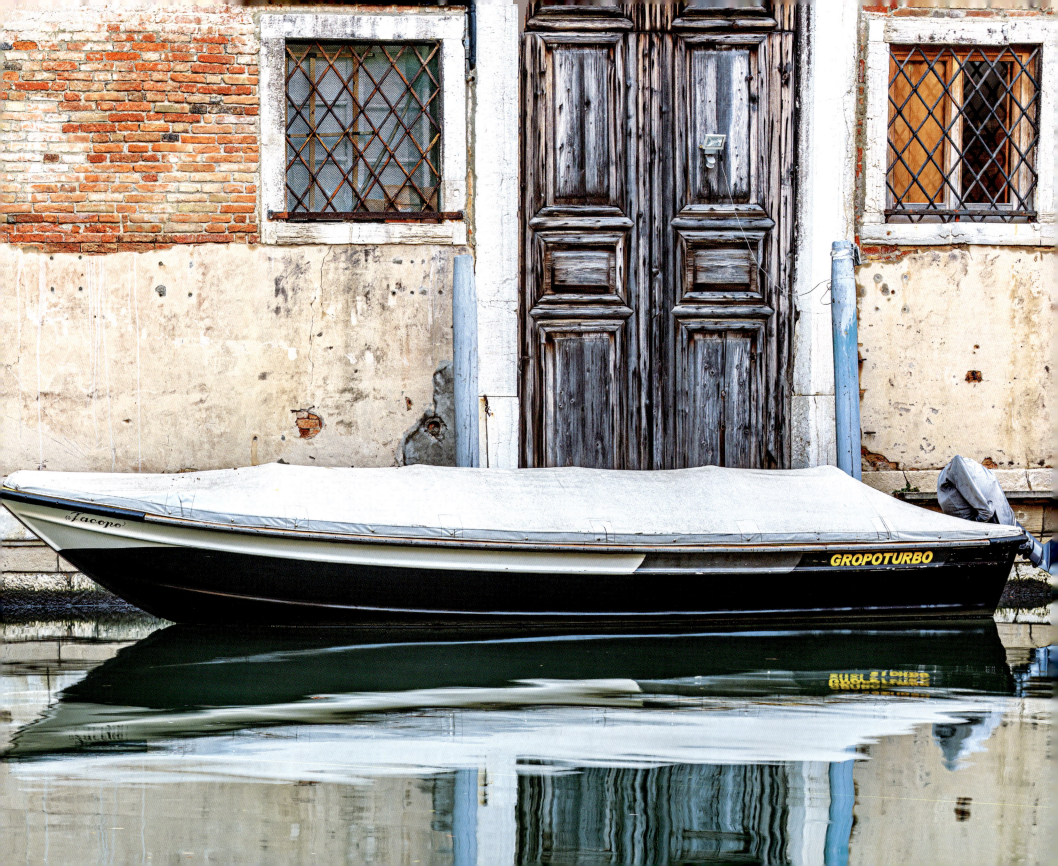

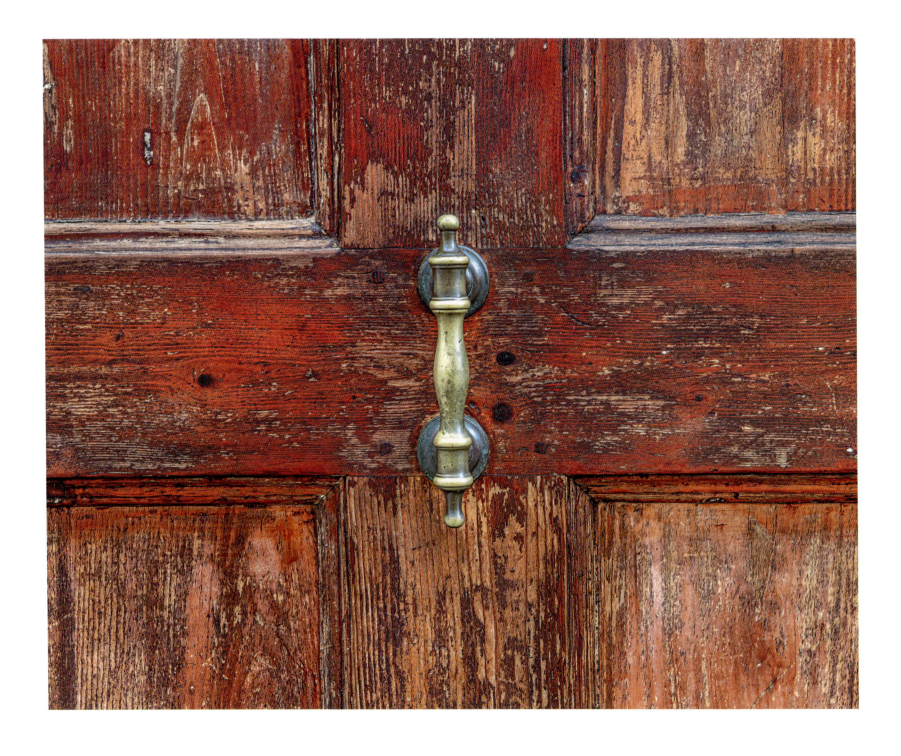

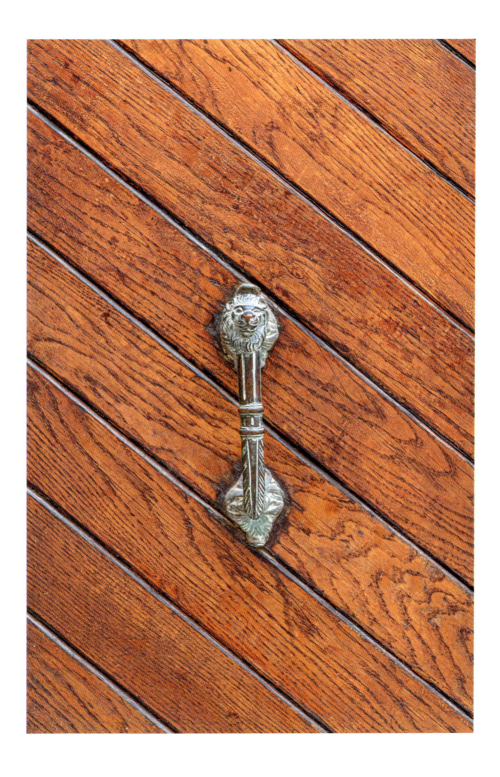

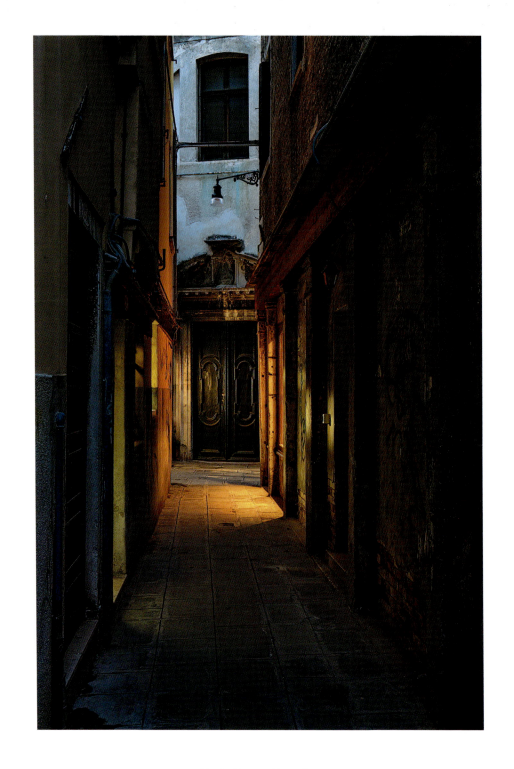

On the Zattere, Dorsoduro

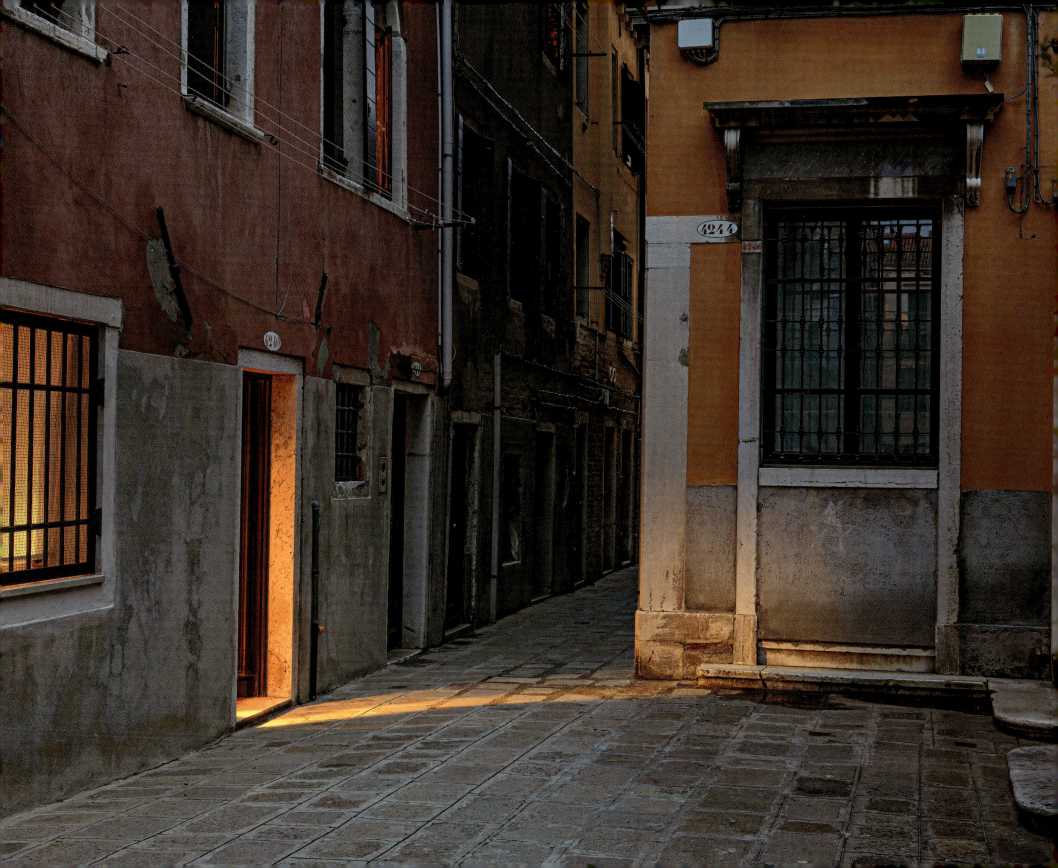

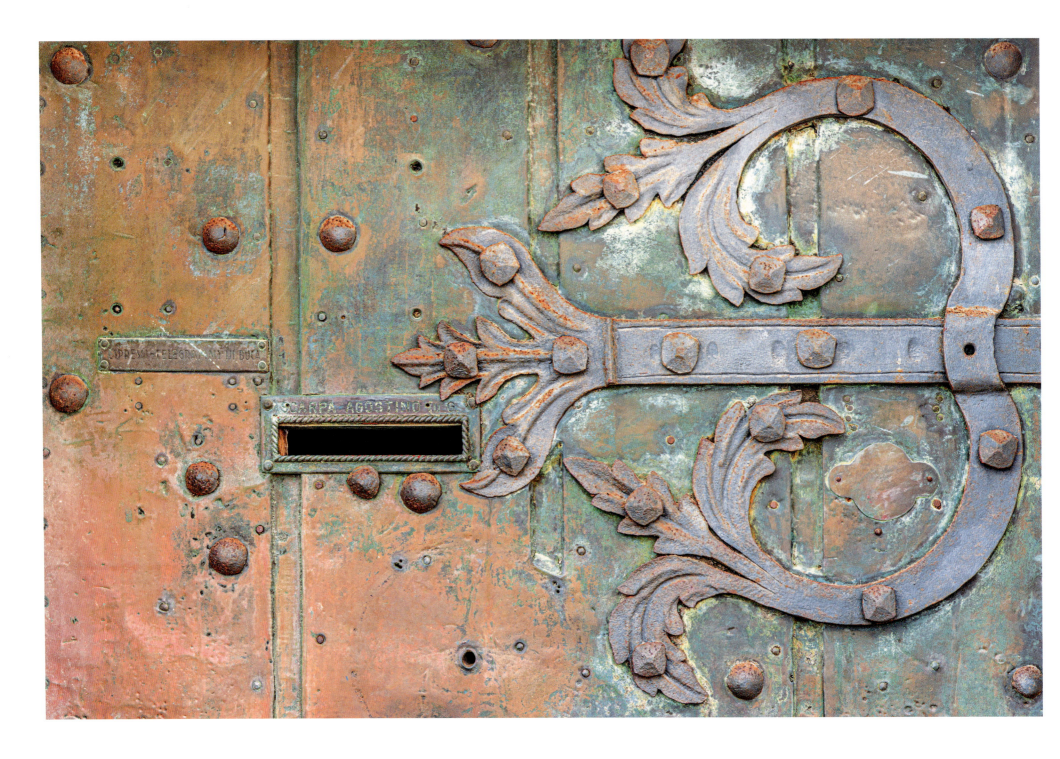

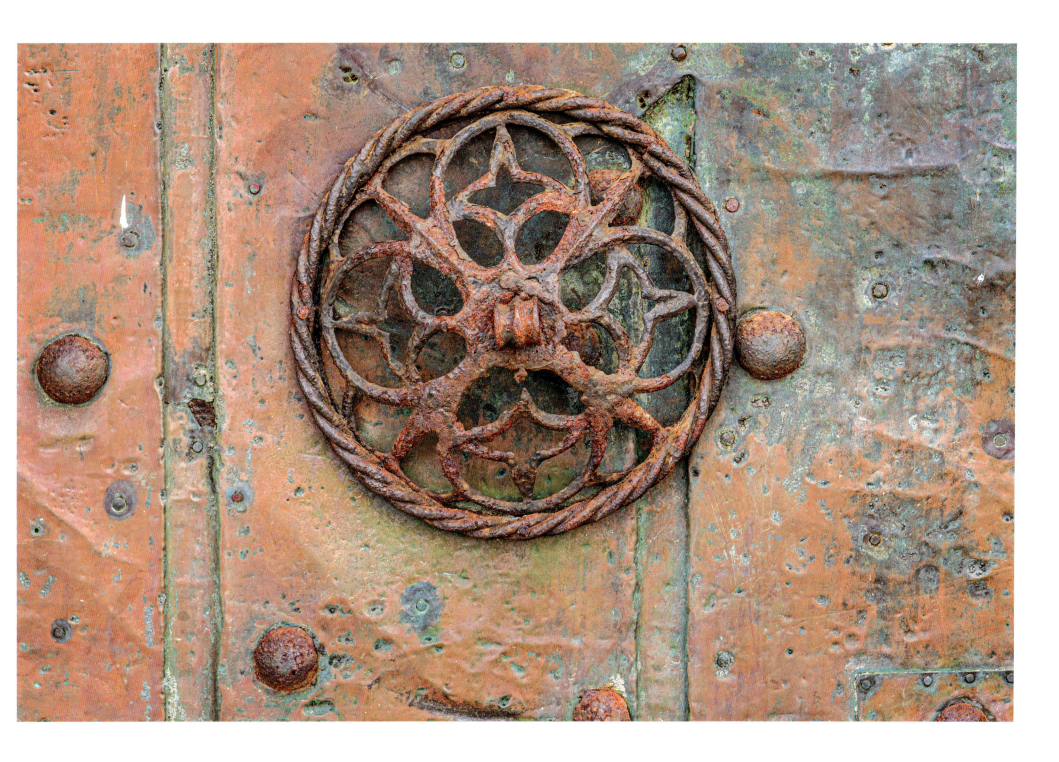

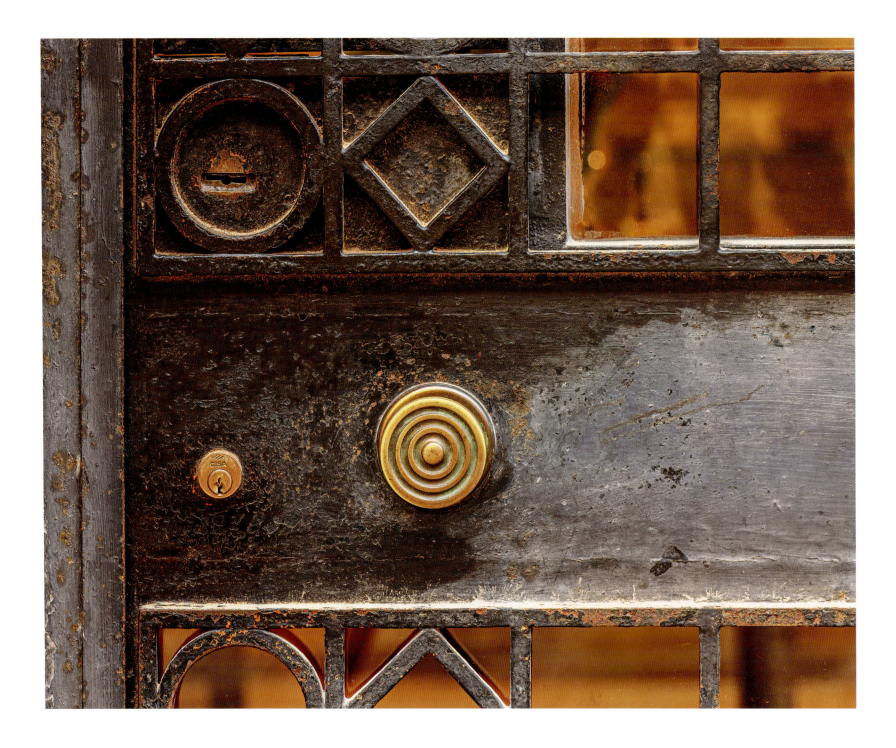

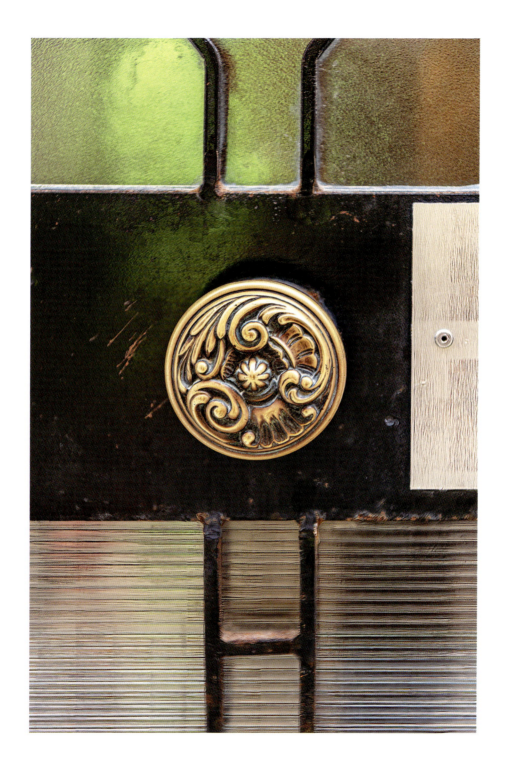

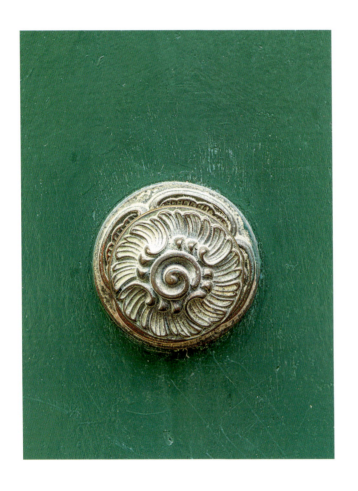
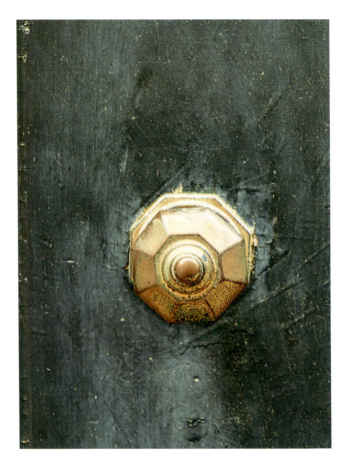

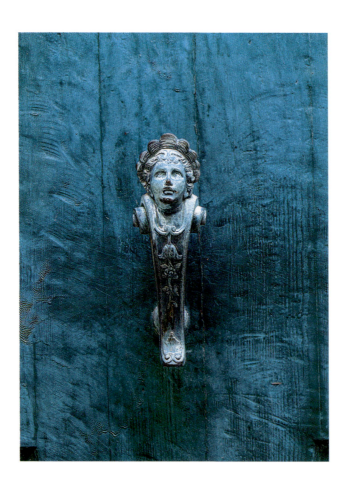 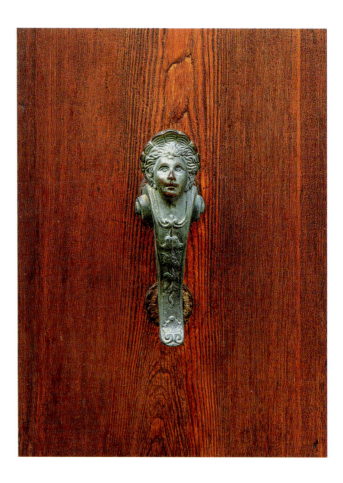

Figurines such as this one may represent Venice herself, or even possibly a goddess, such as the Greek goddess Hestia, the goddess of hearth and home.

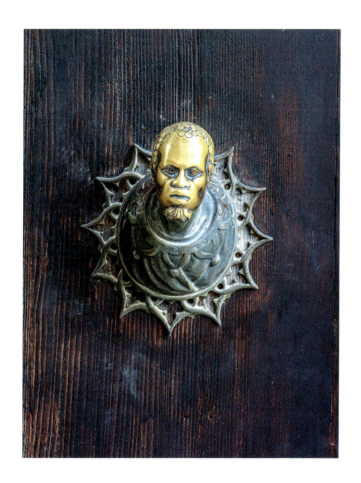
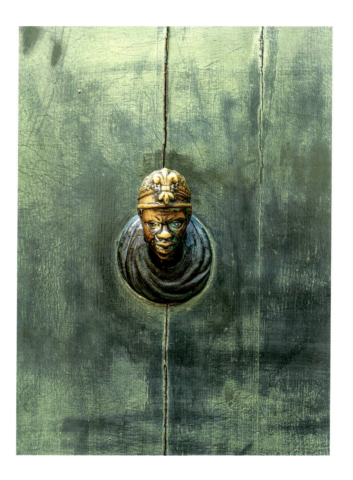

While distasteful by today's standards, ownership of domestic slaves was a sign of status and prestige many centuries ago. Even monasteries would own slaves. War prisoners and victims of pirate raids in the Balkans, North Africa, Turkey, and Syria could end up, through slave markets, in Venice.

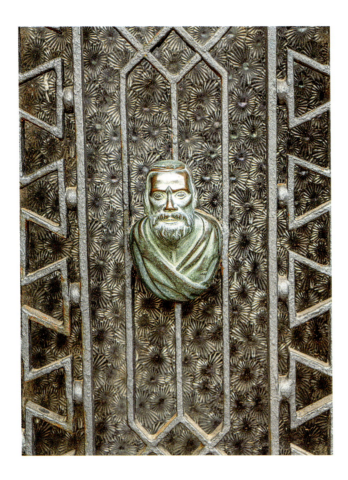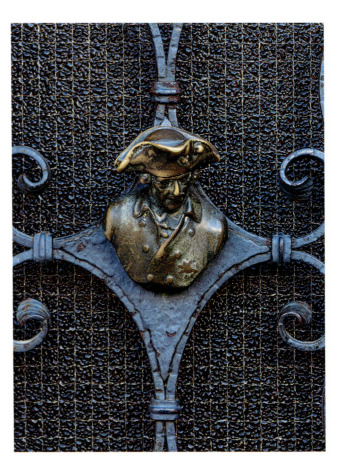

Right: A tricorne hat started as a French fashion in Versailles in the eighteenth century, and it spread to all social classes. Depicting a figure with a tricorne hat might have been a fashion statement of the resident.

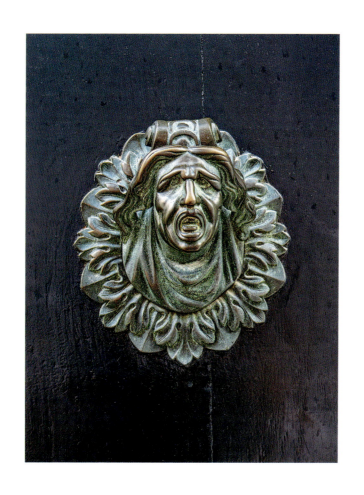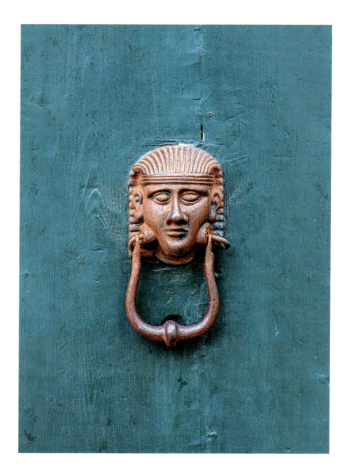

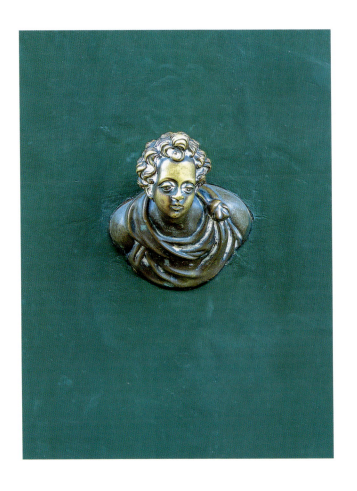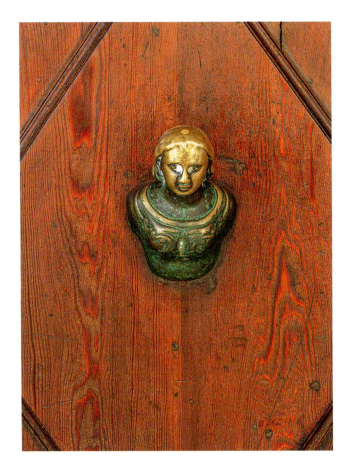

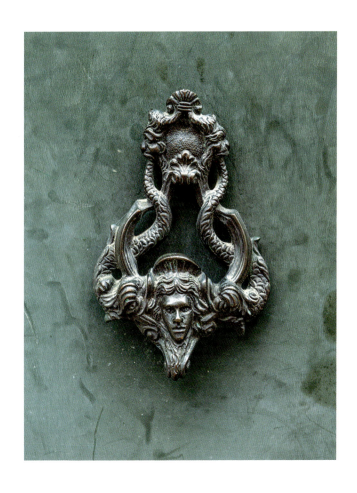
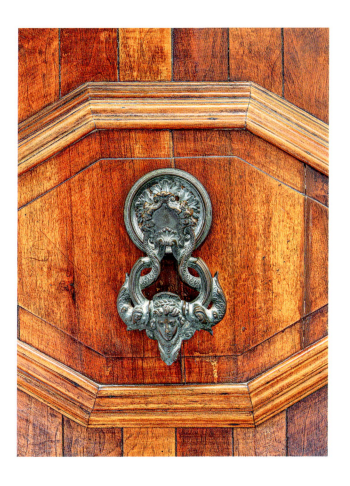

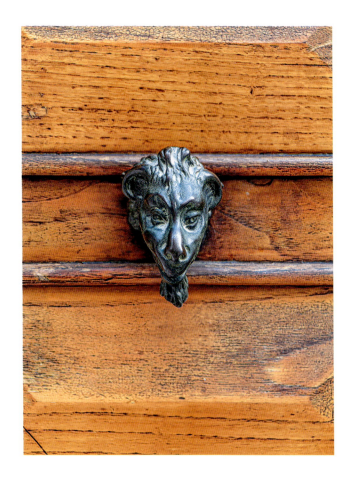
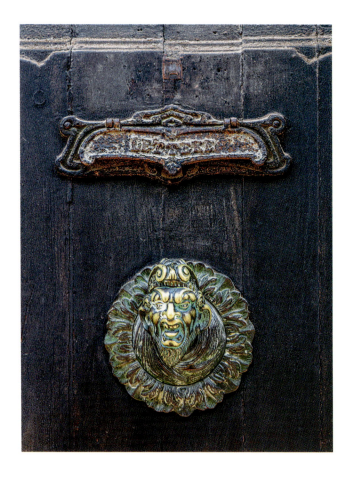

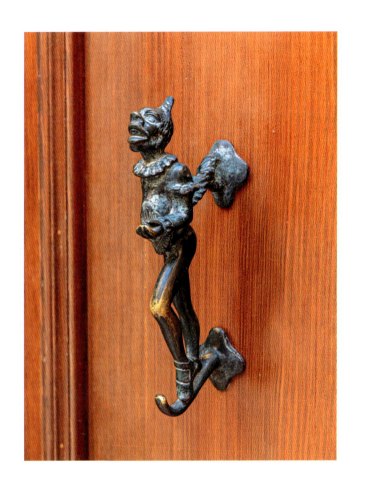
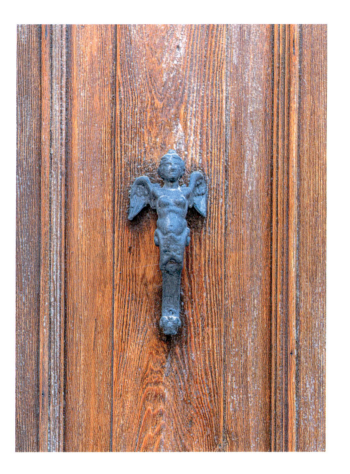

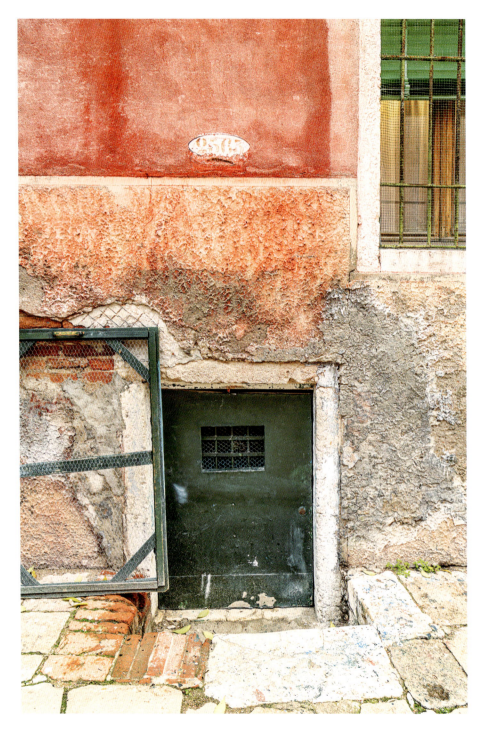

A door in Castello reveals how the level of the street surface has risen over the centuries, likely to cope with flooding.

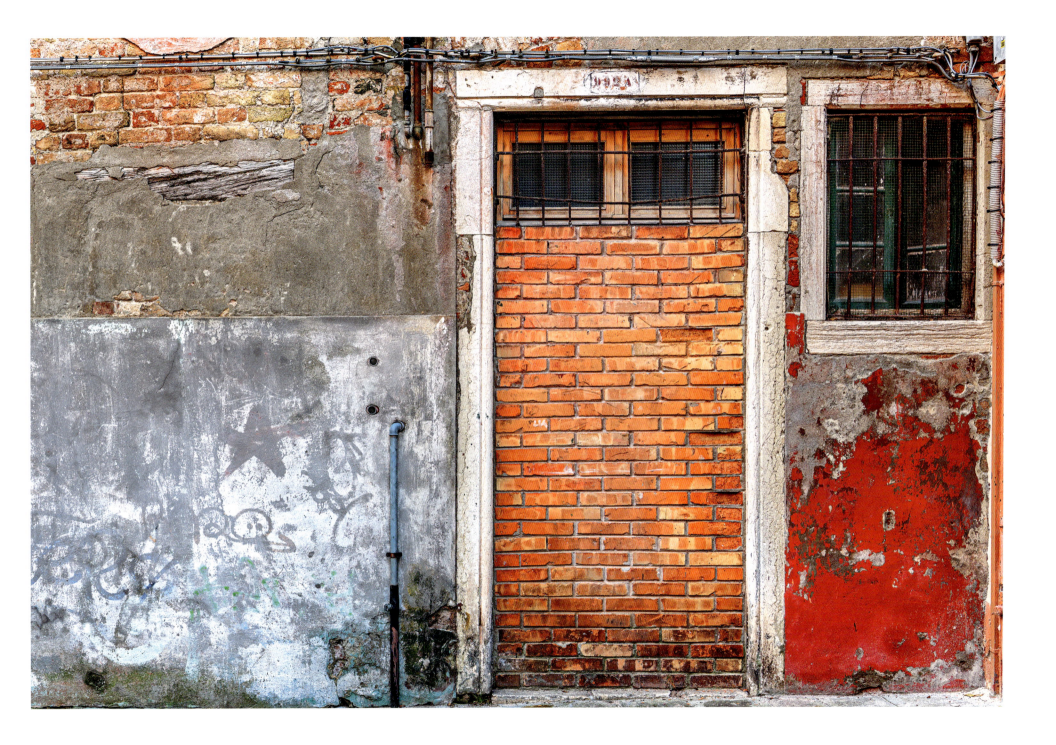

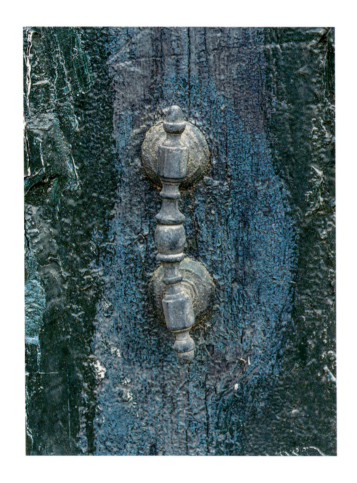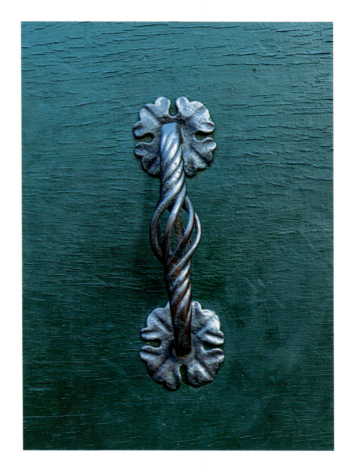

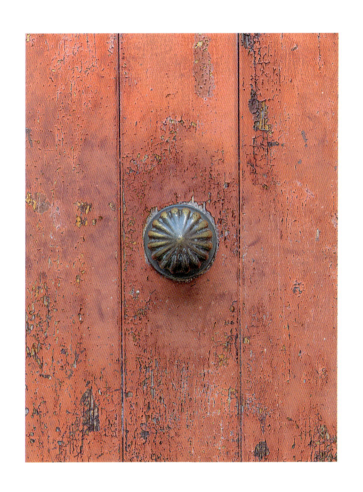 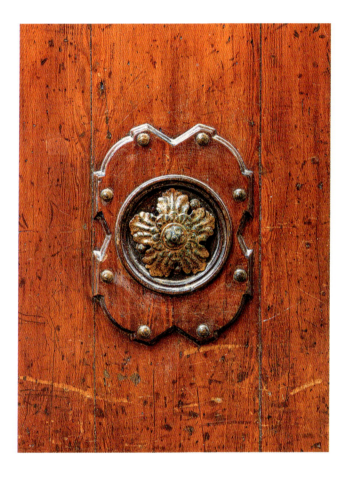

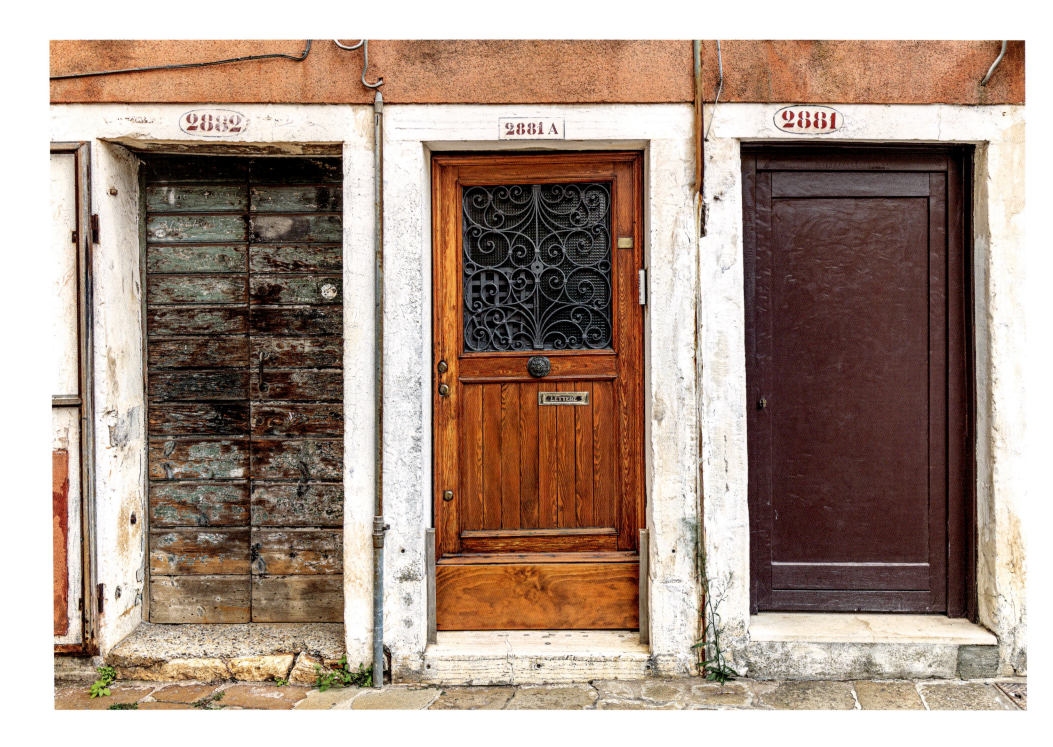

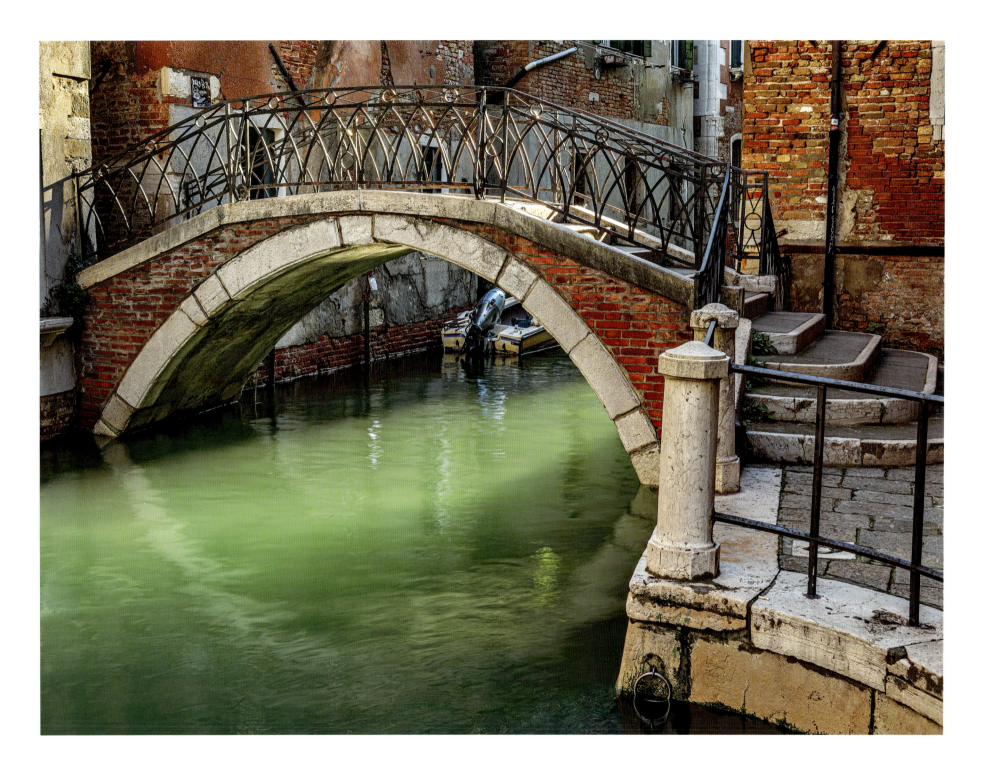
Shaft of sunlight, San Polo

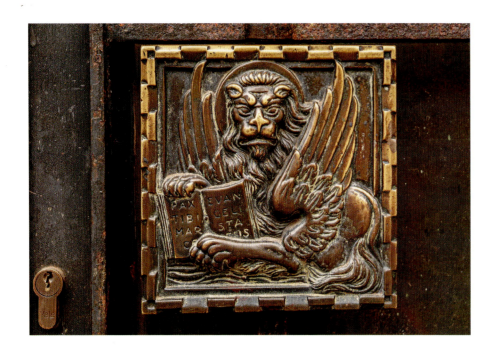 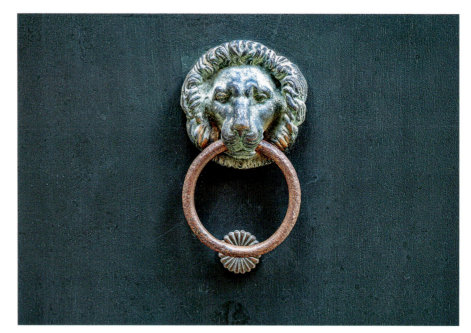

Left: The winged lion is the symbol of both St. Mark and Venice. According to a legend, St. Mark had a vision: an angel that looked like a lion (the winged lion) showed itself to the saint and announced that he would be buried in Venice.

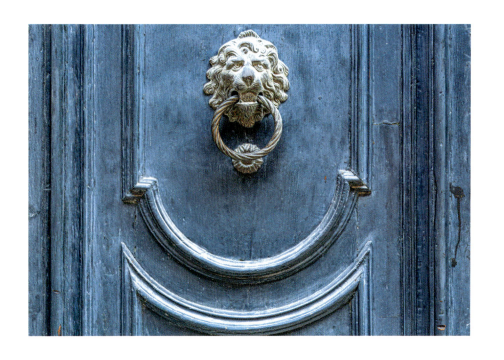
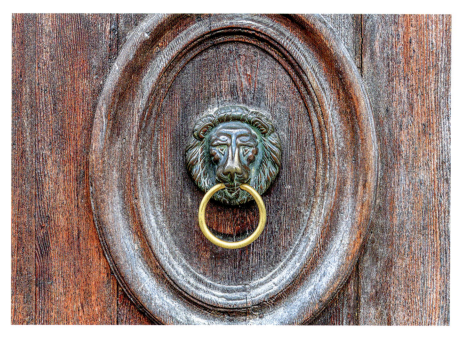

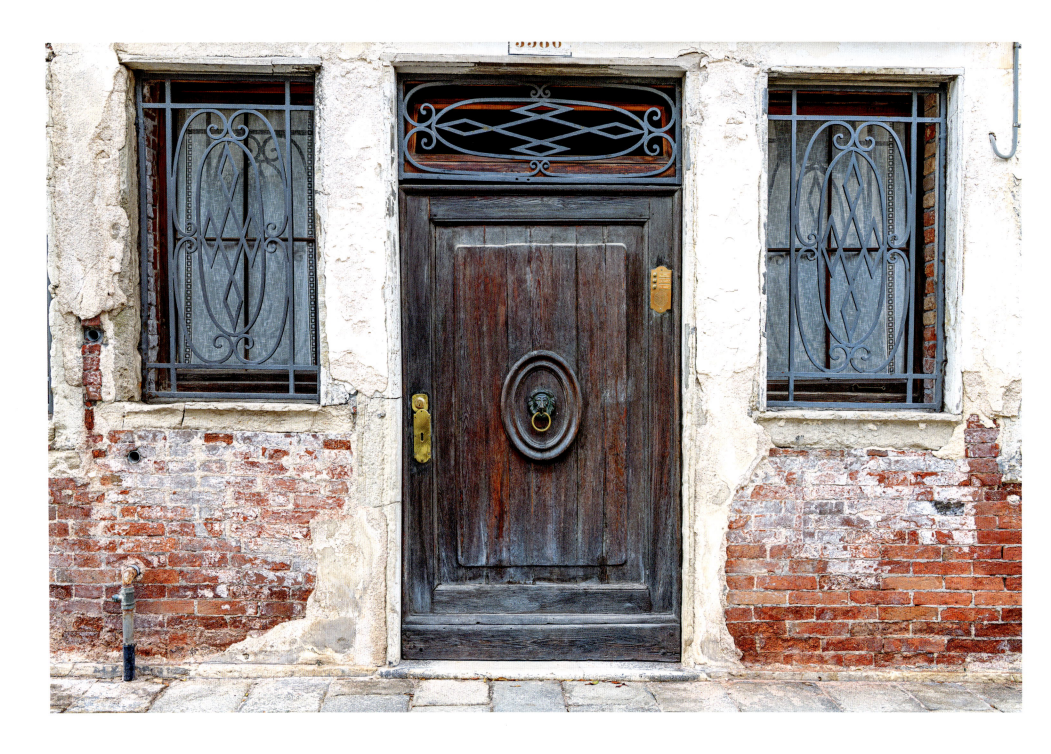

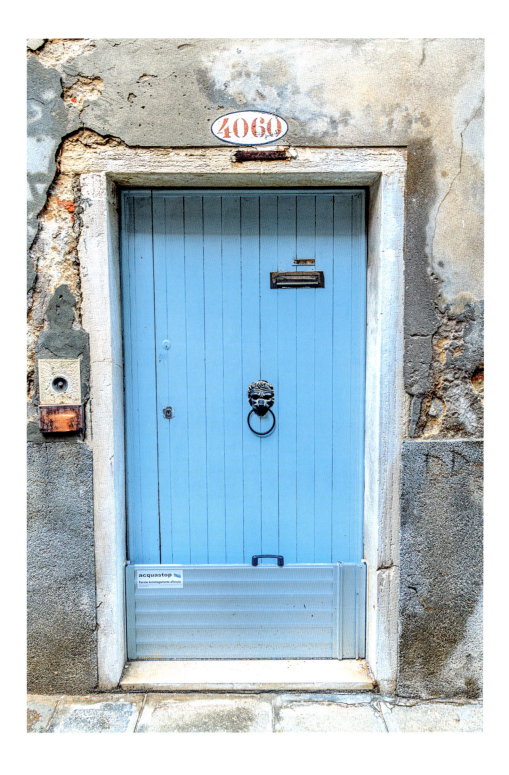

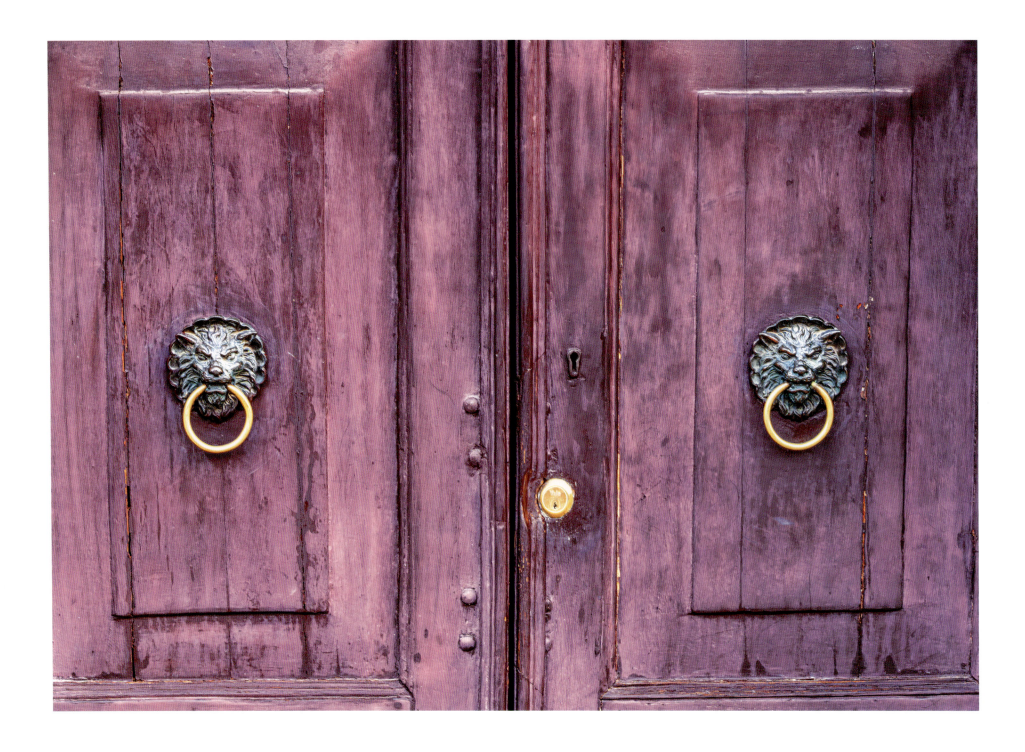

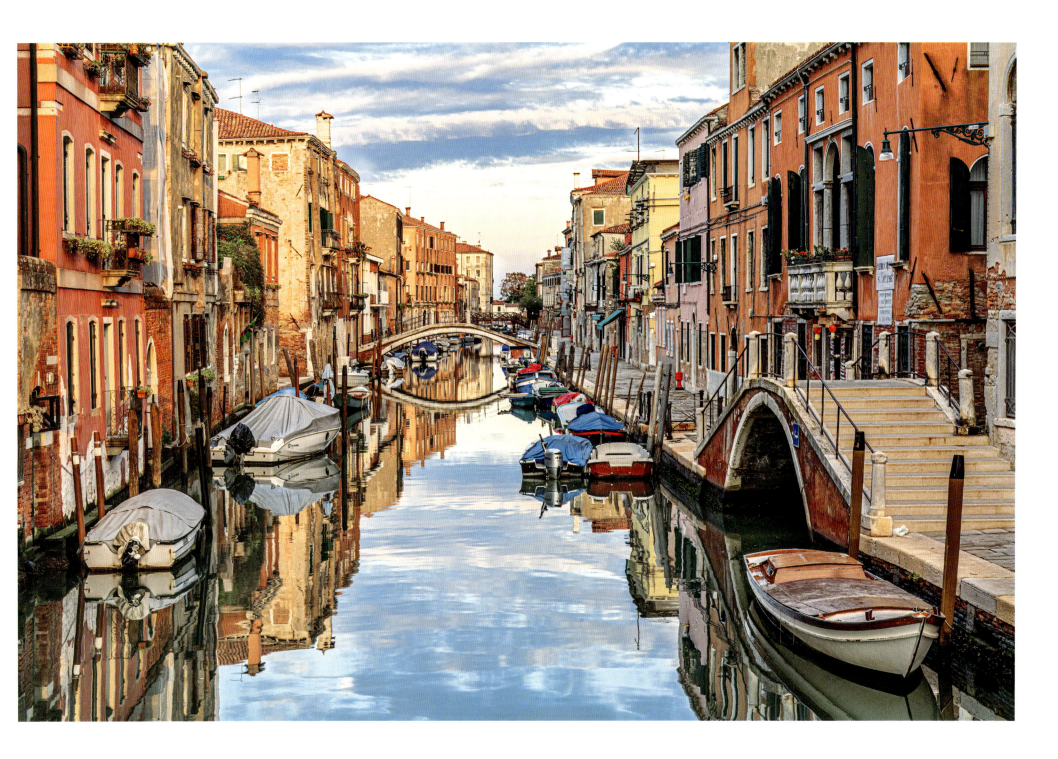

Rio di S. Alvise, Cannaregio

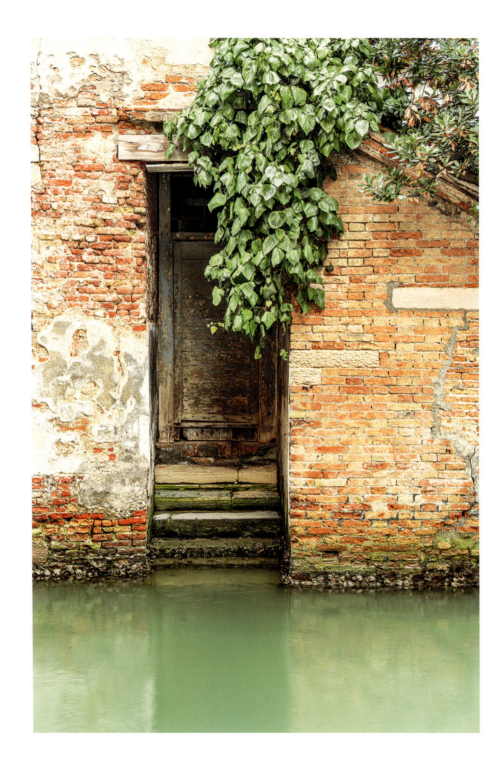

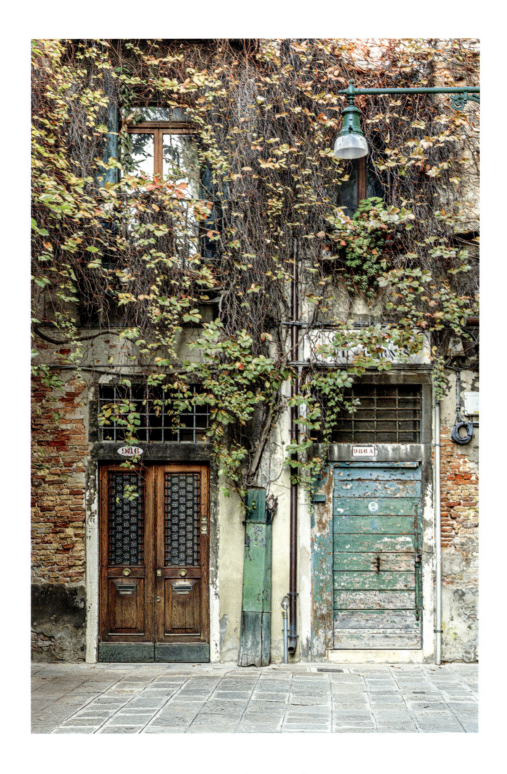

Doors with ivy, San Polo

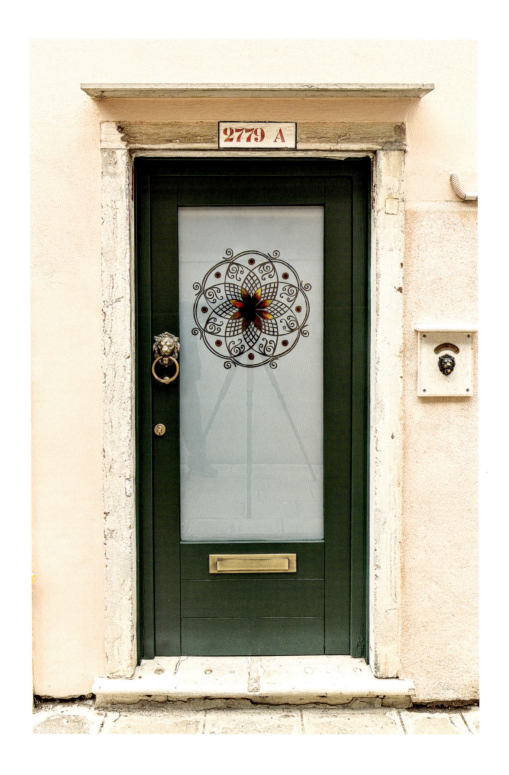

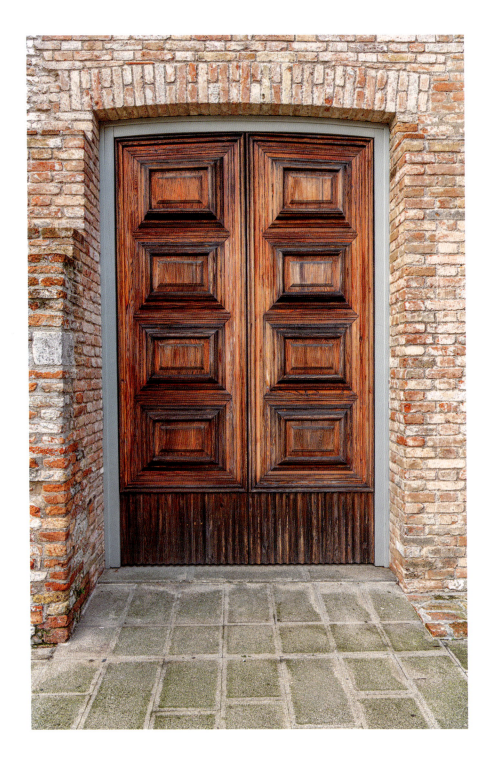
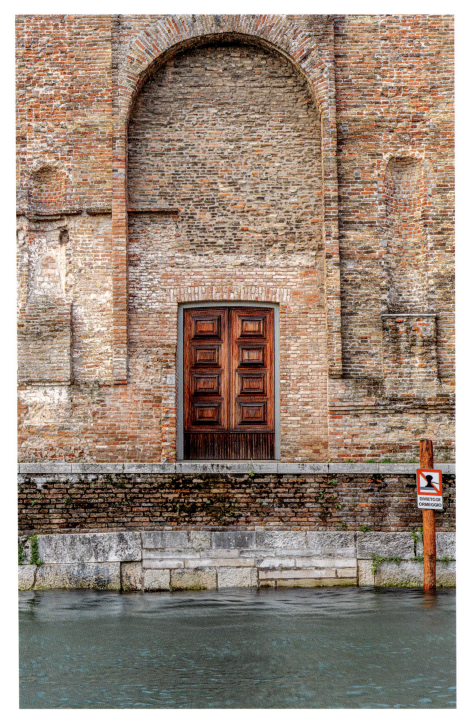

Left: Scuola Grande di Santa Maria della Misericordia, Cannaregio

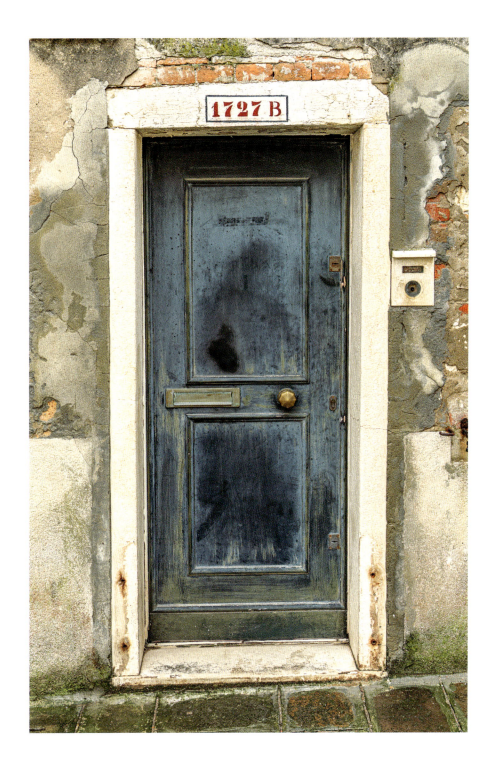
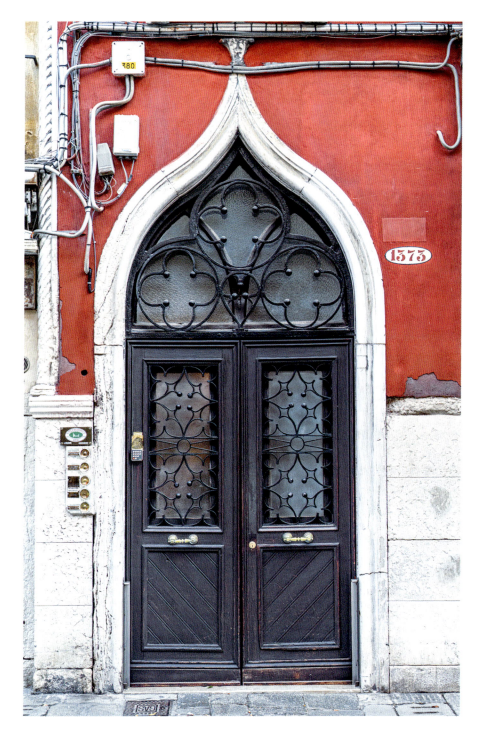

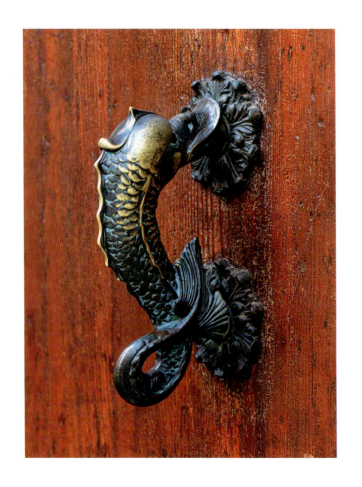
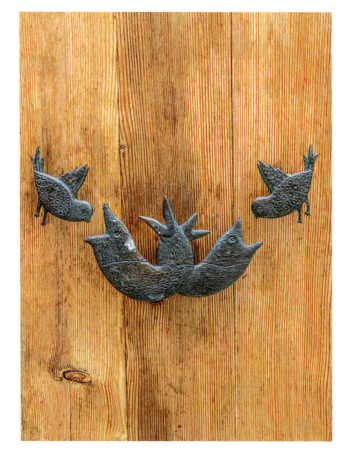

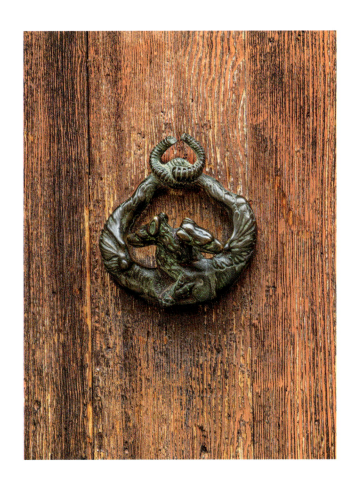
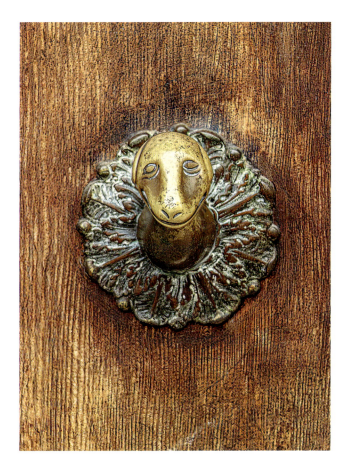

111

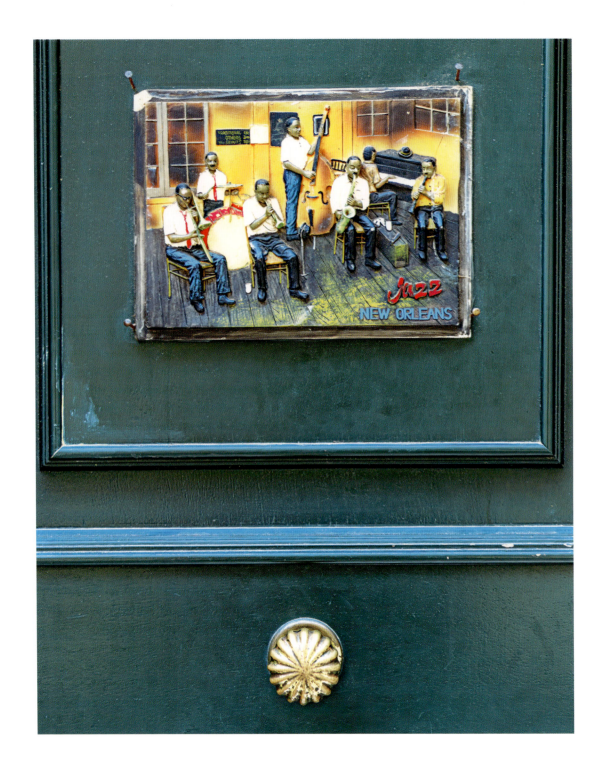

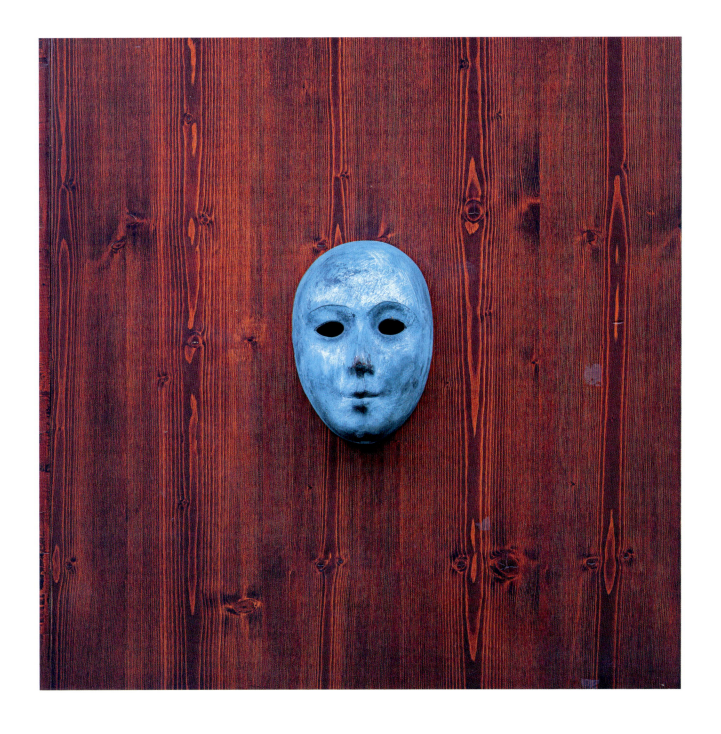

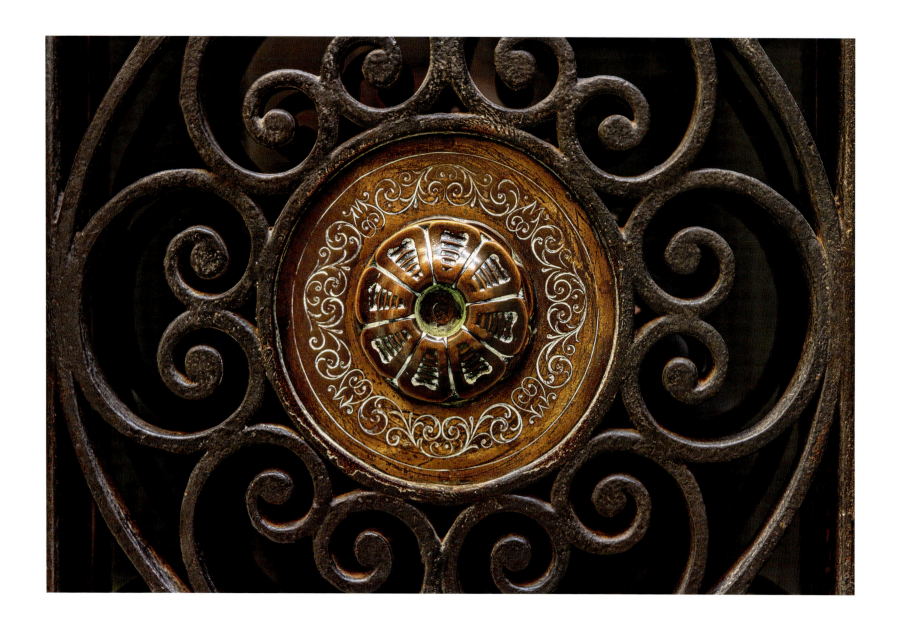

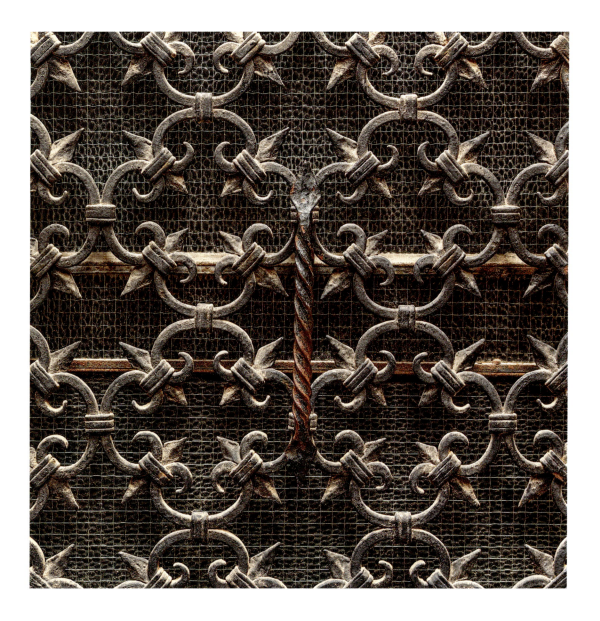

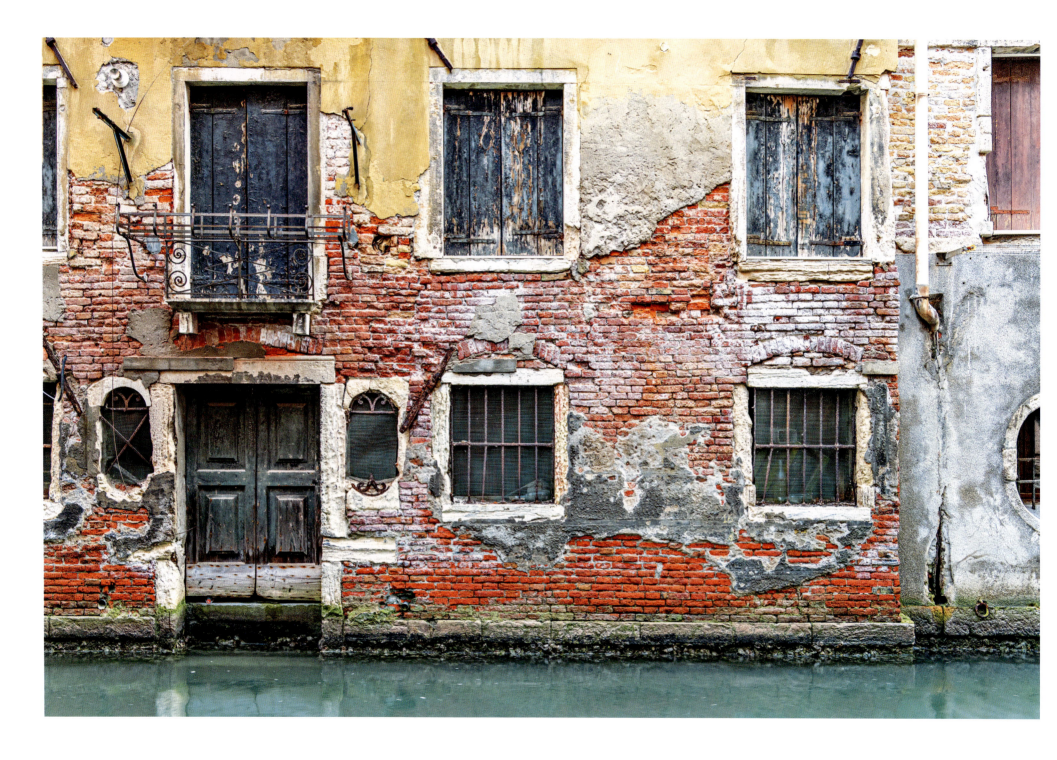
Canal doors, Castello

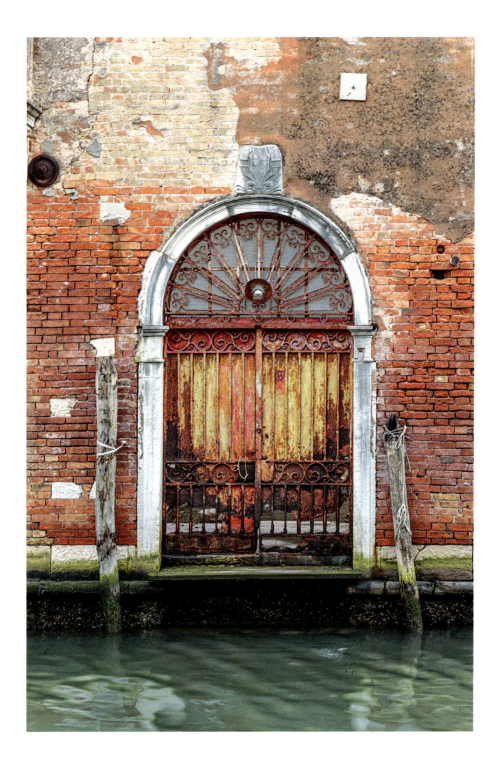

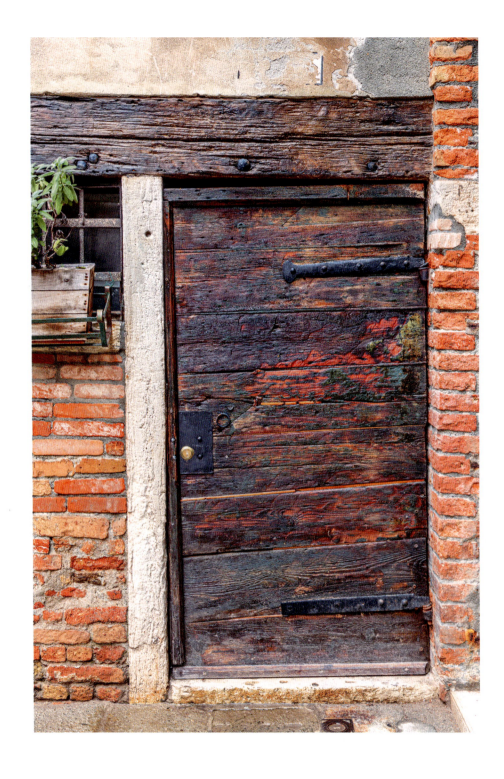

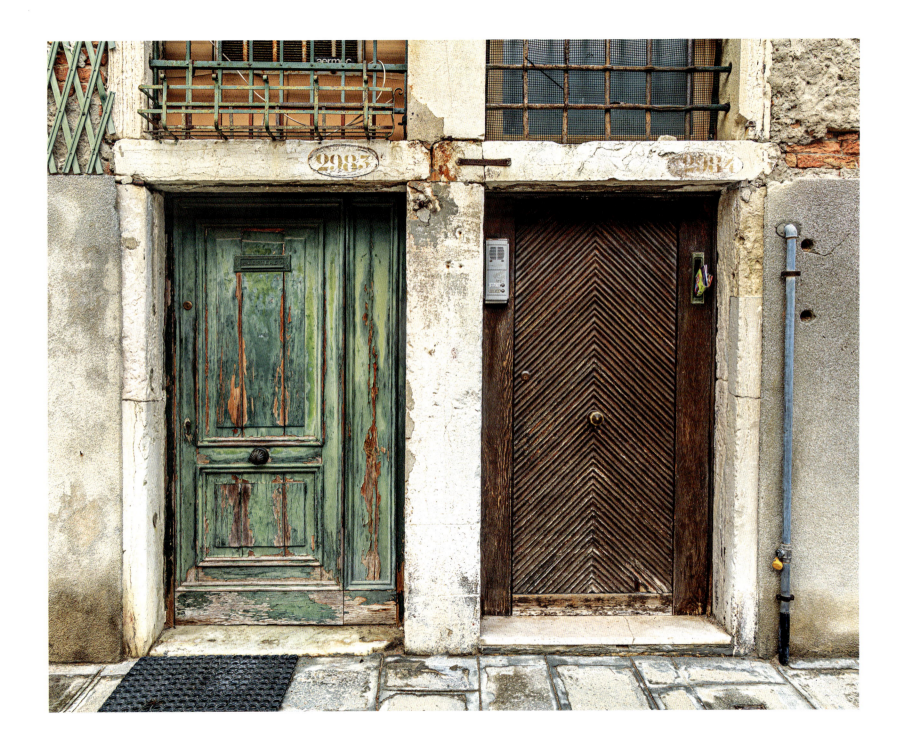

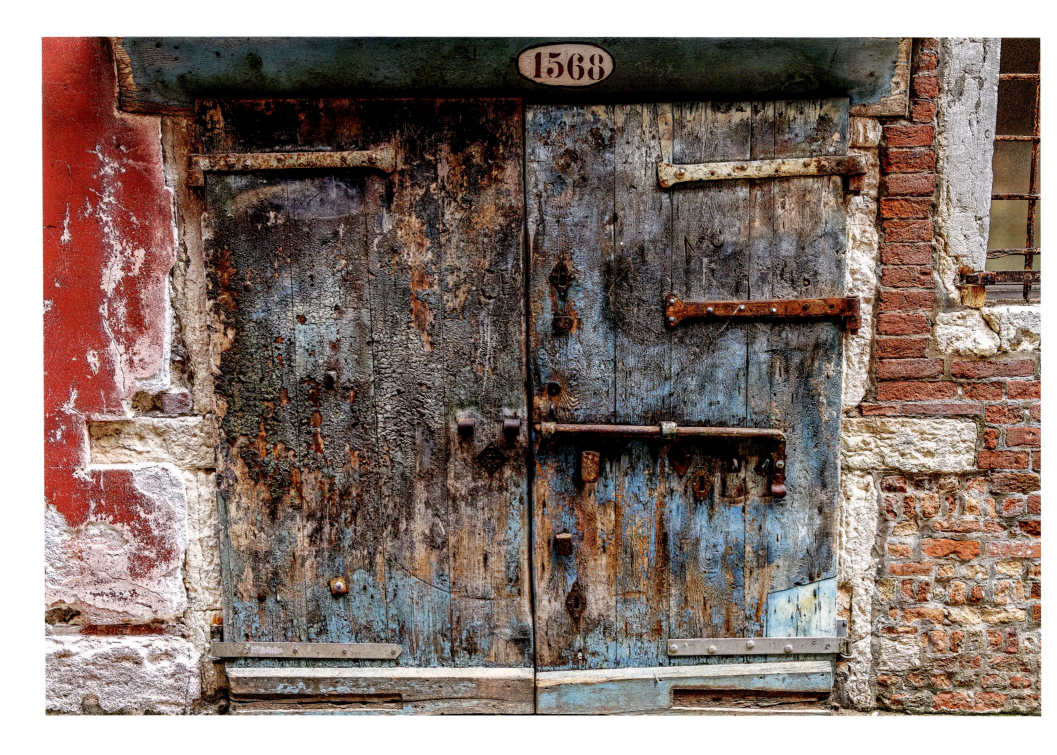

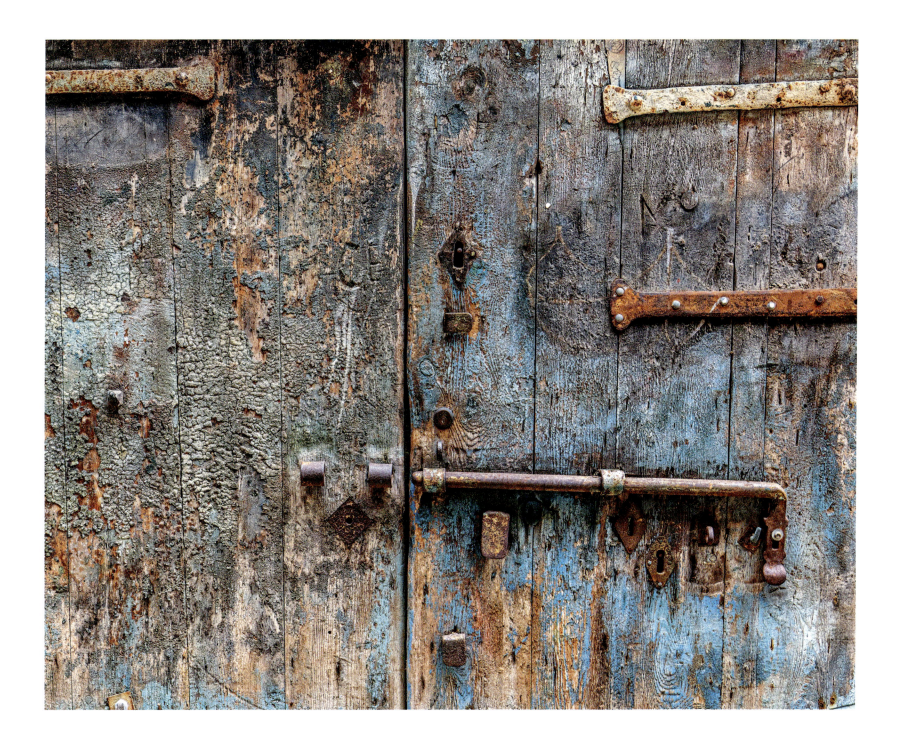

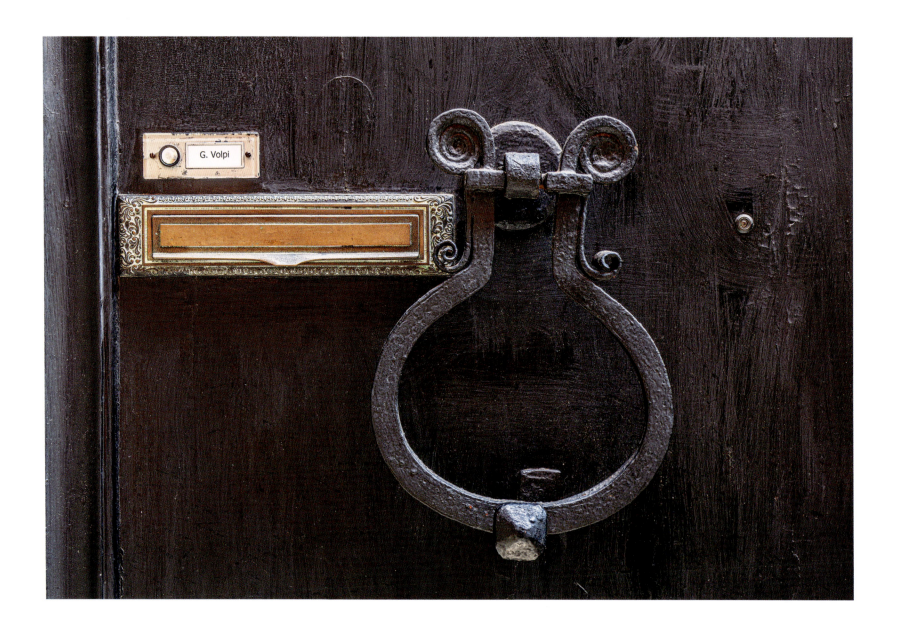

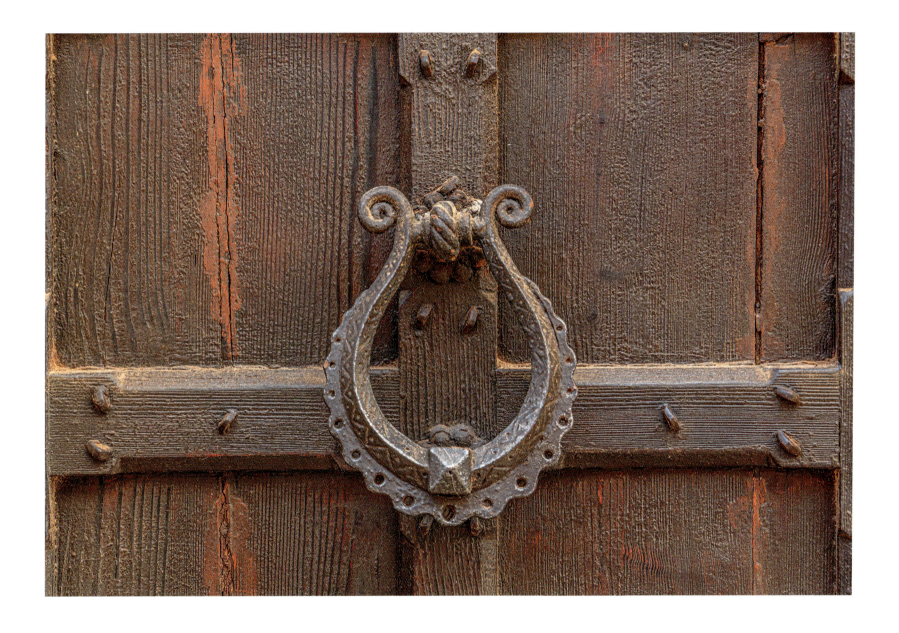

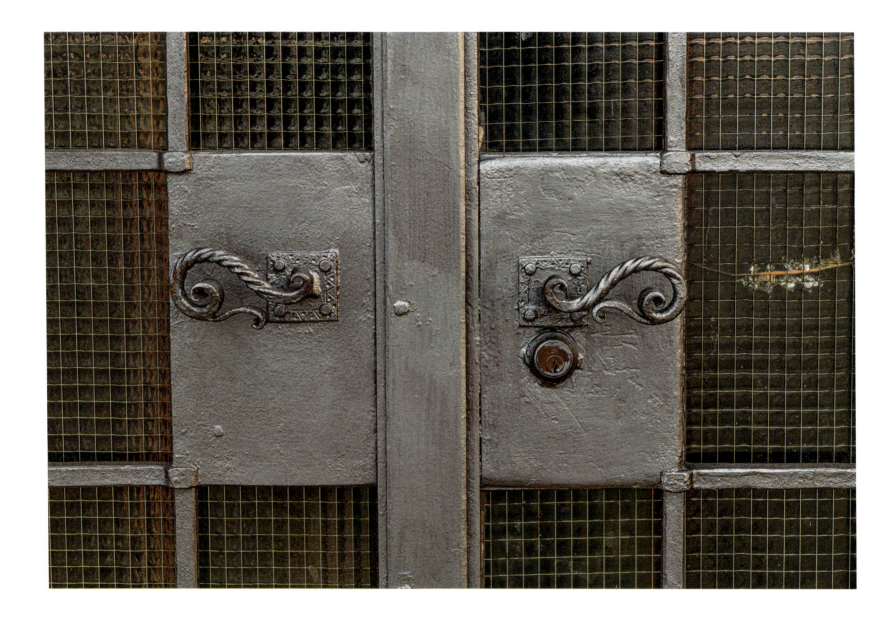

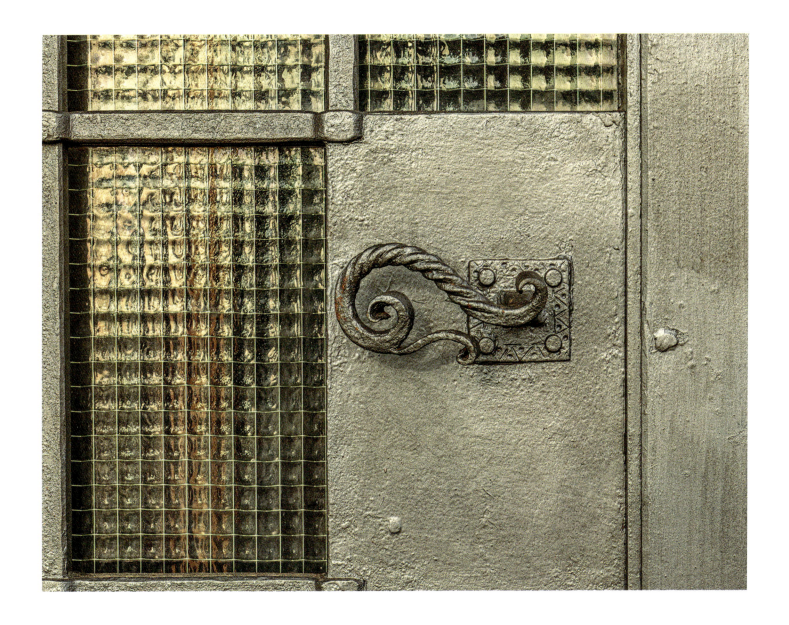

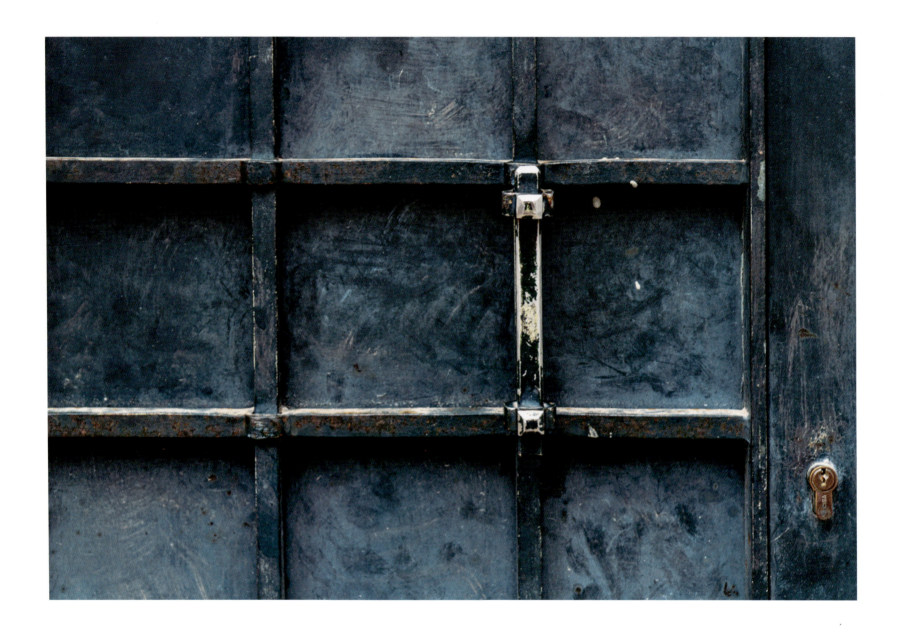

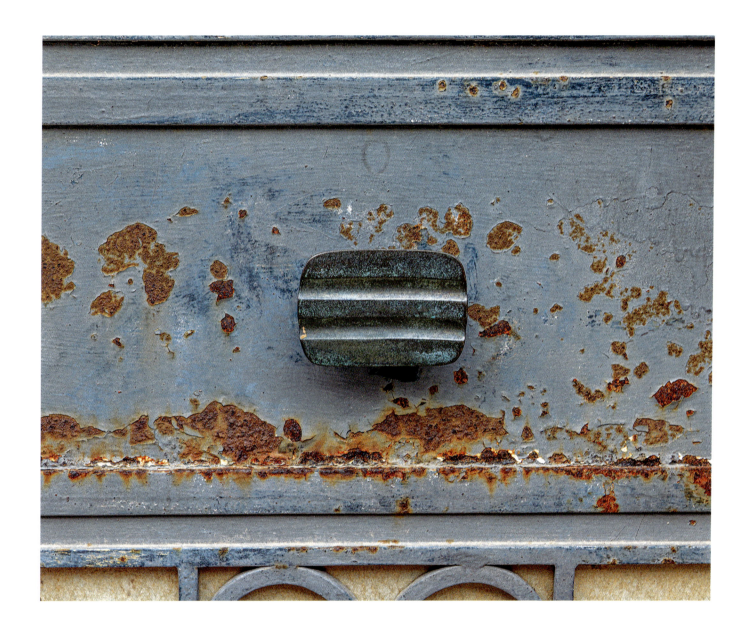

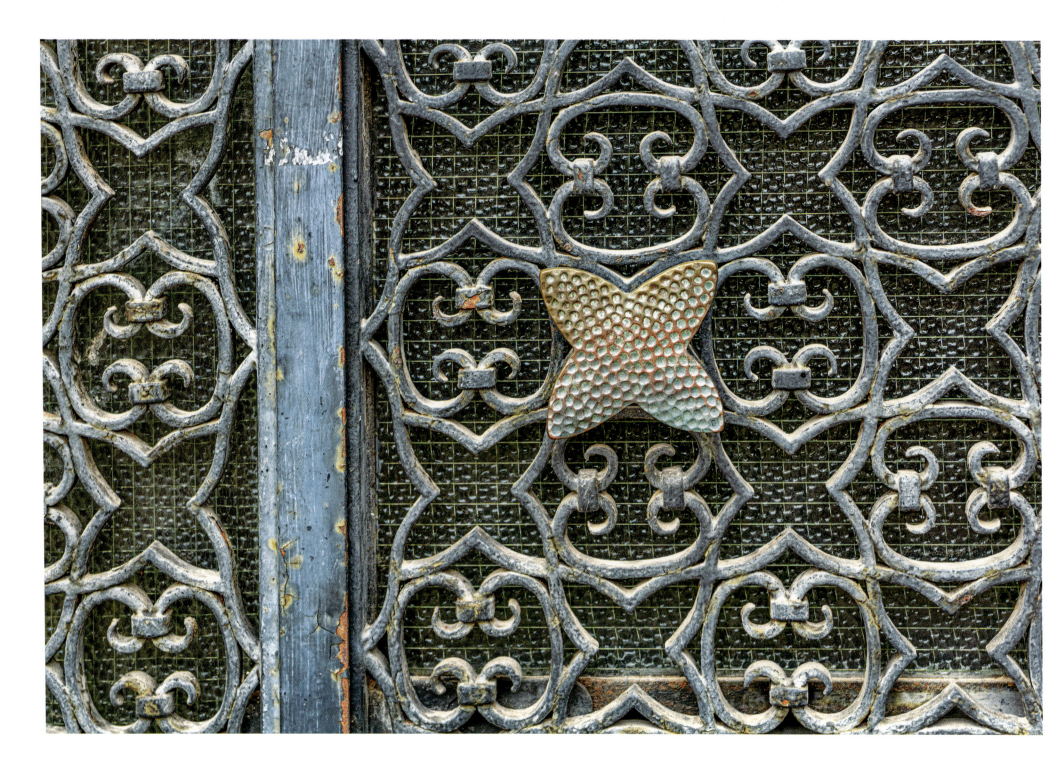

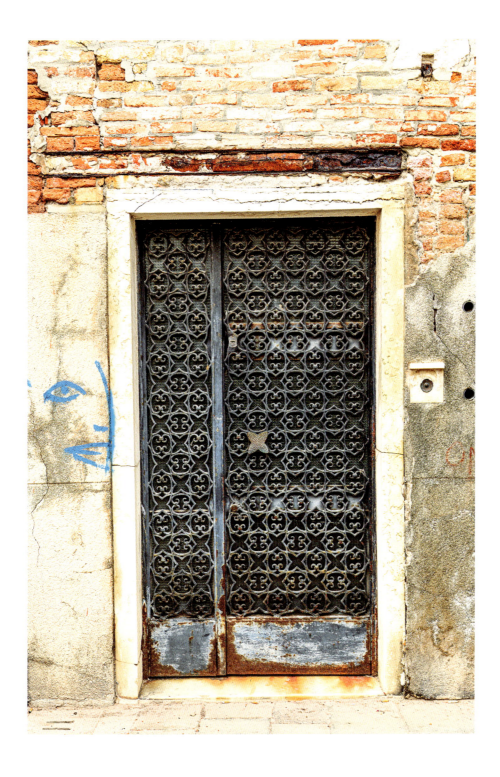

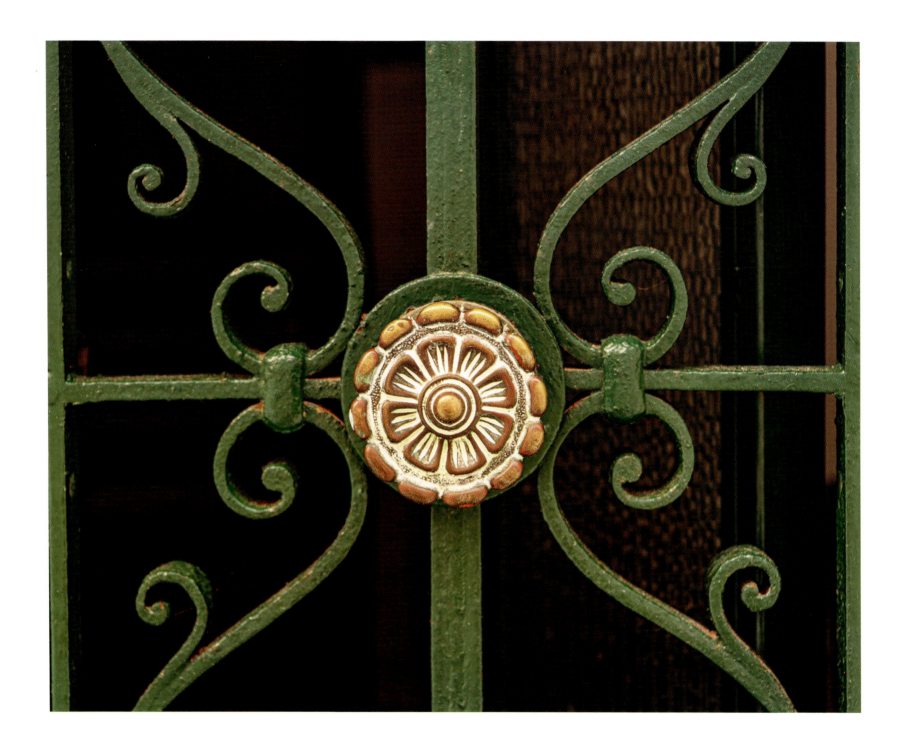

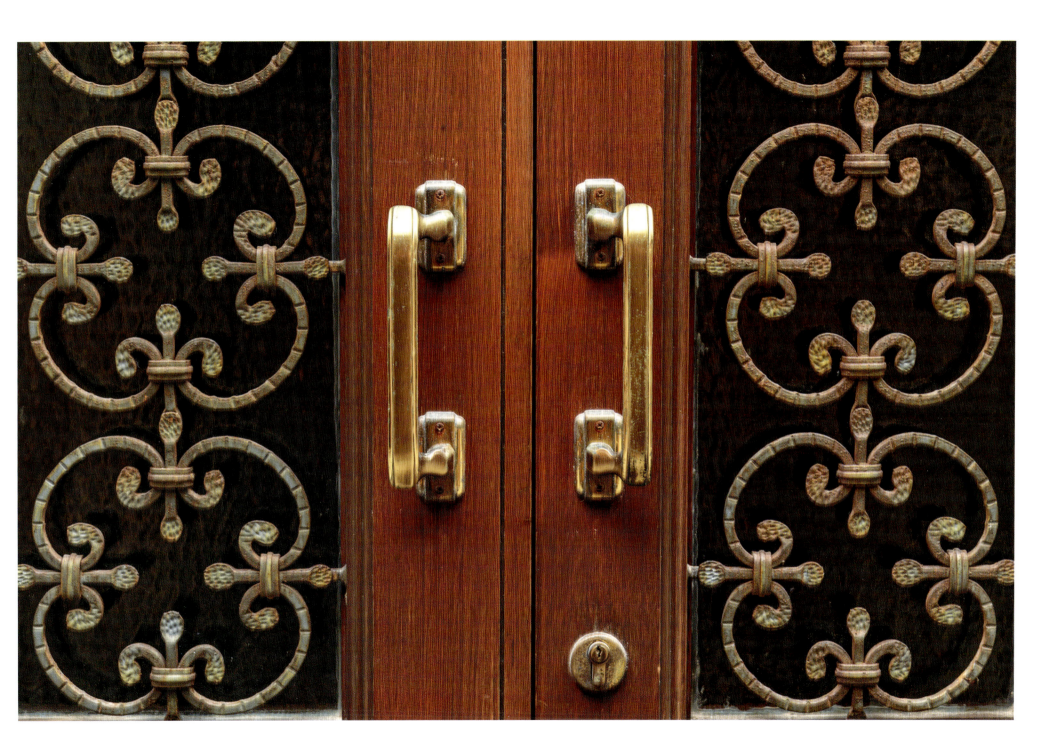

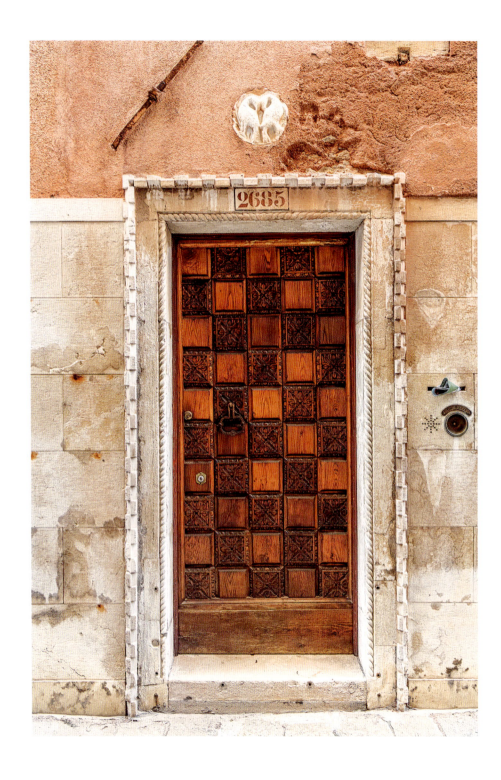

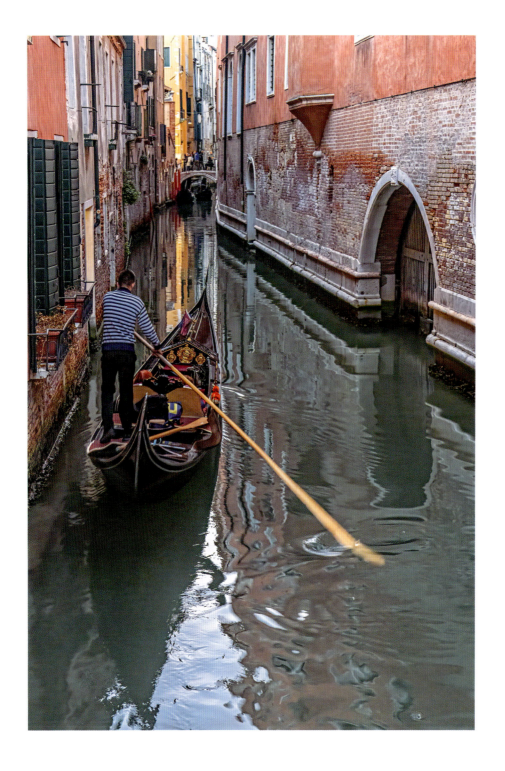

Gondoliere, San Marco

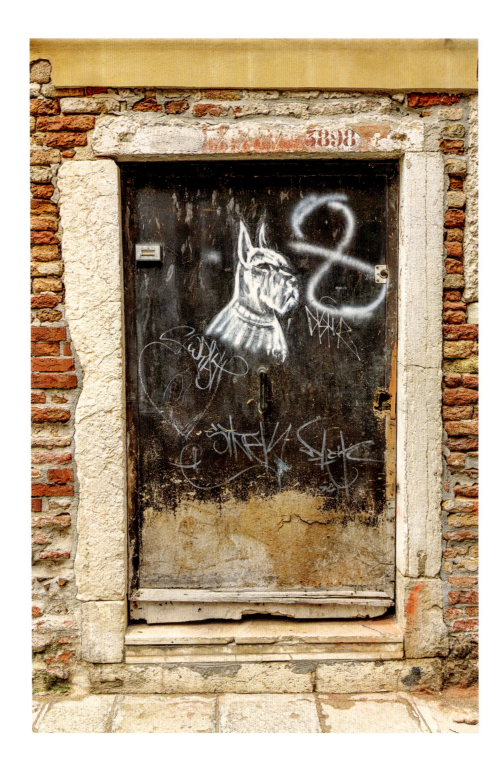

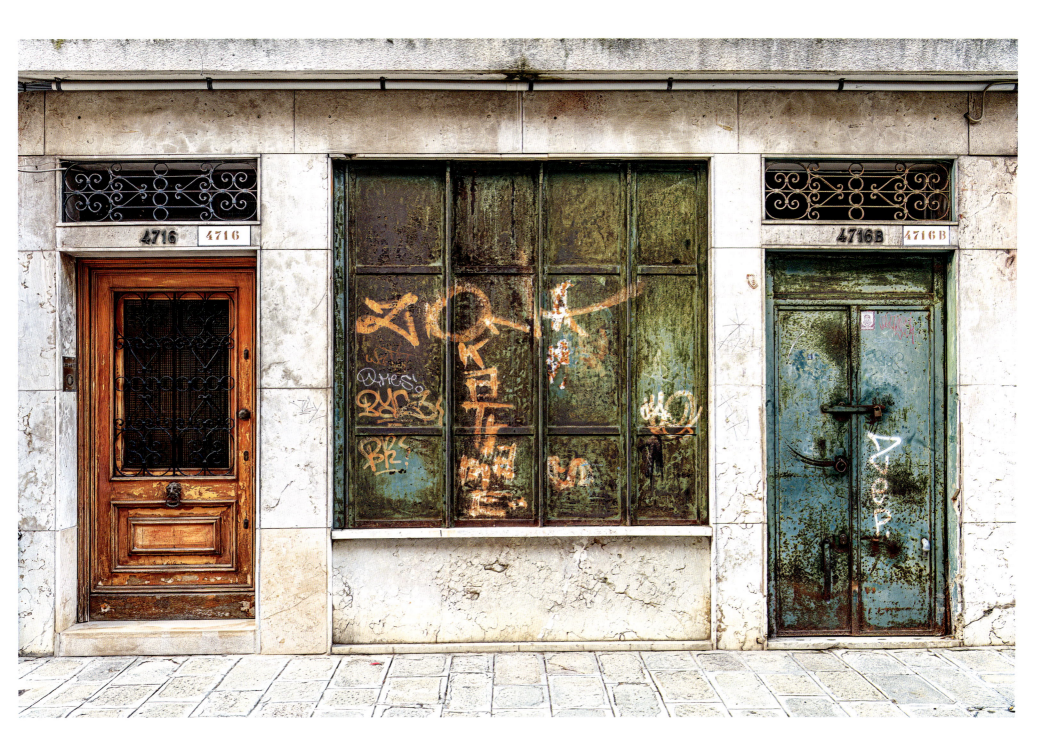

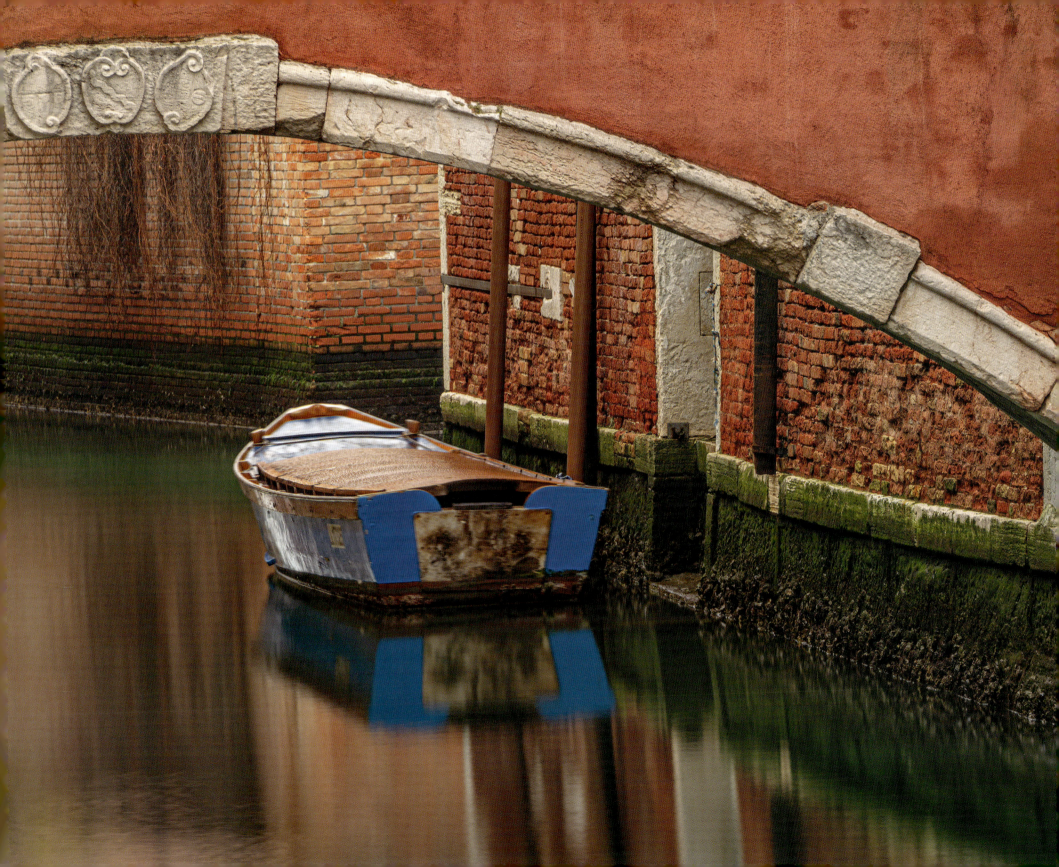

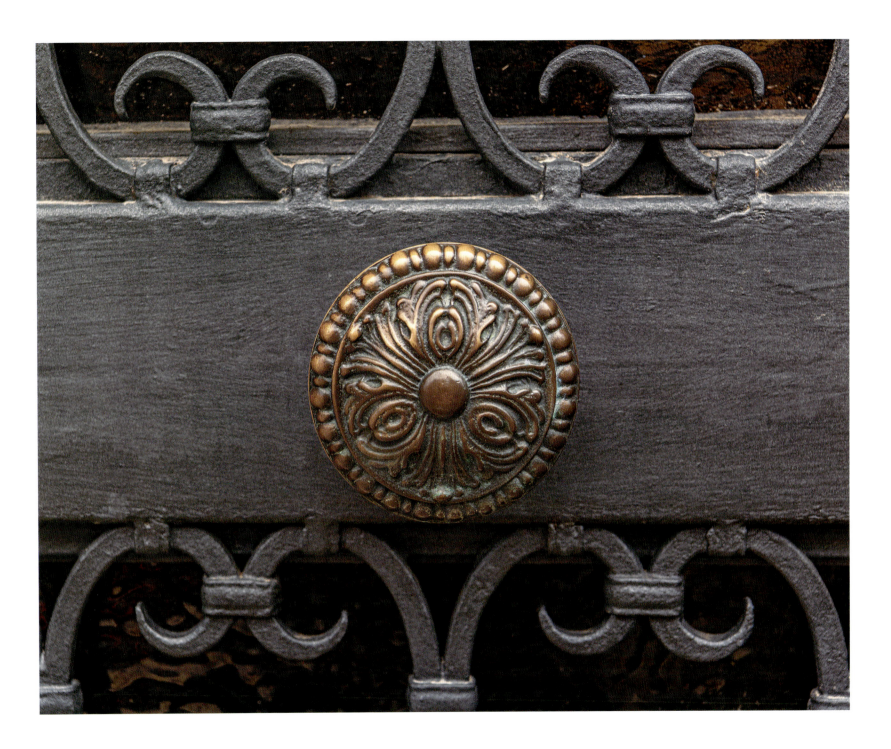

Opposite: Ponte Sant'Andrea

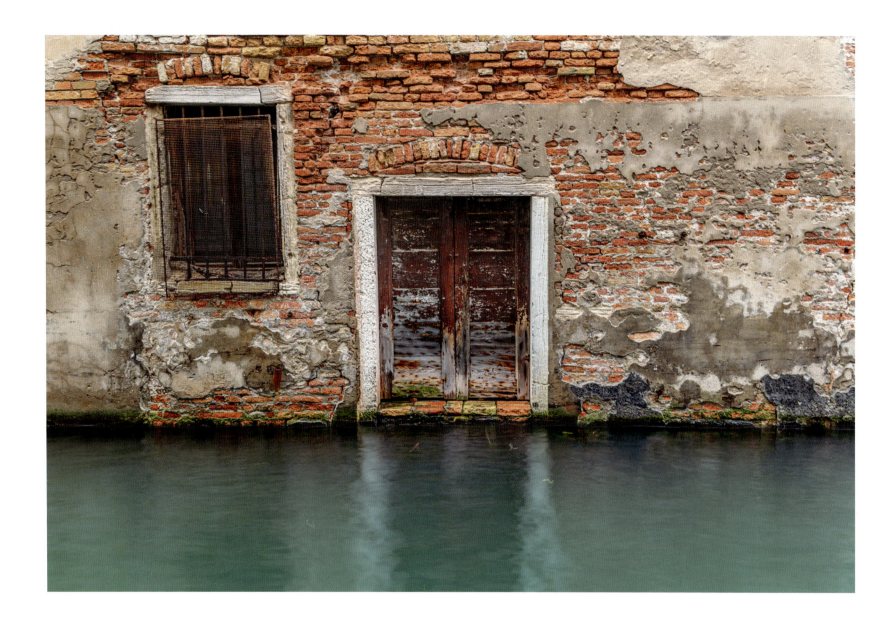

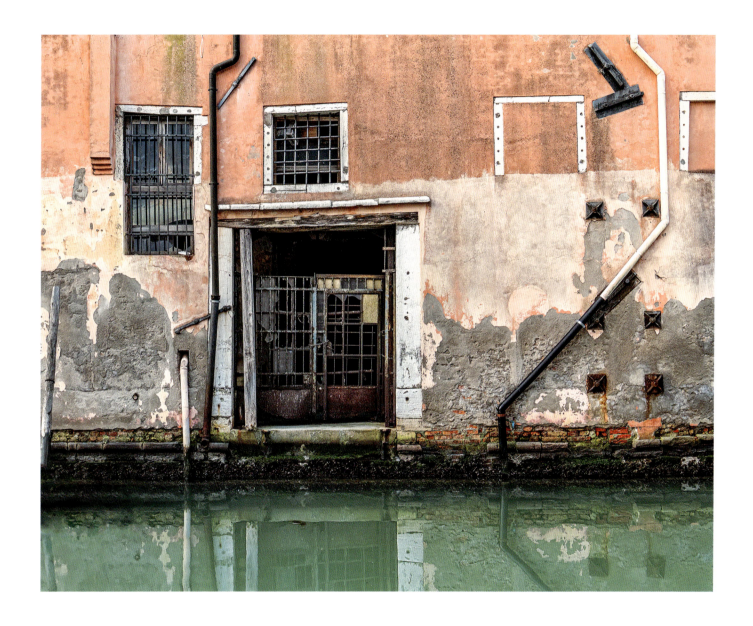

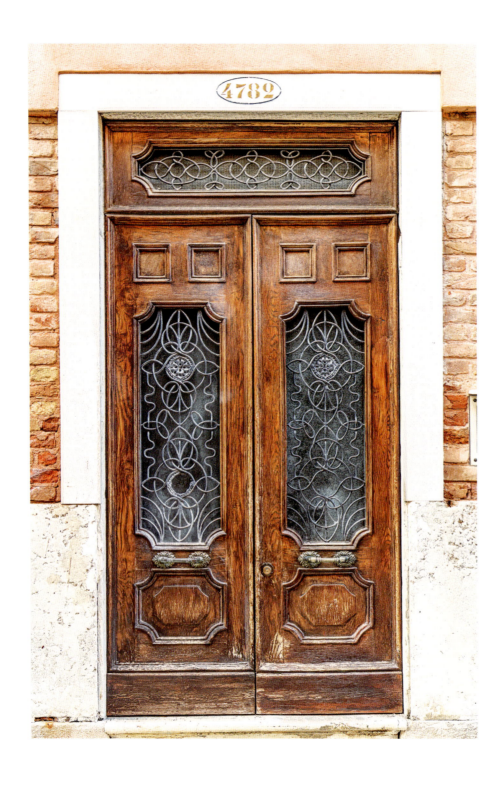

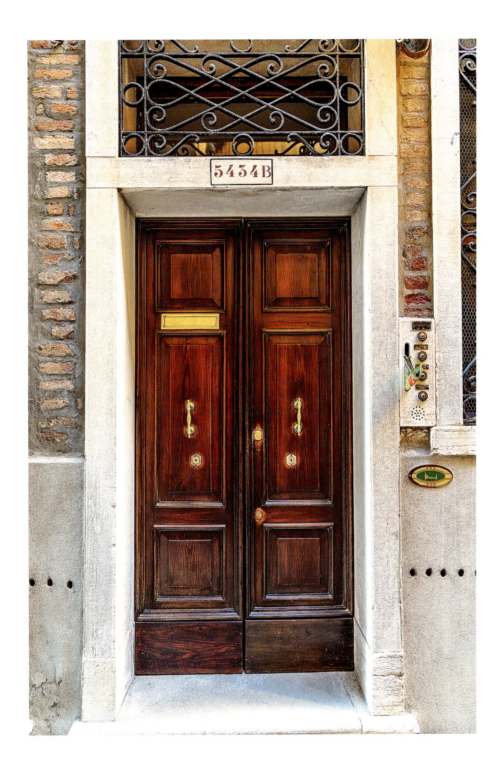

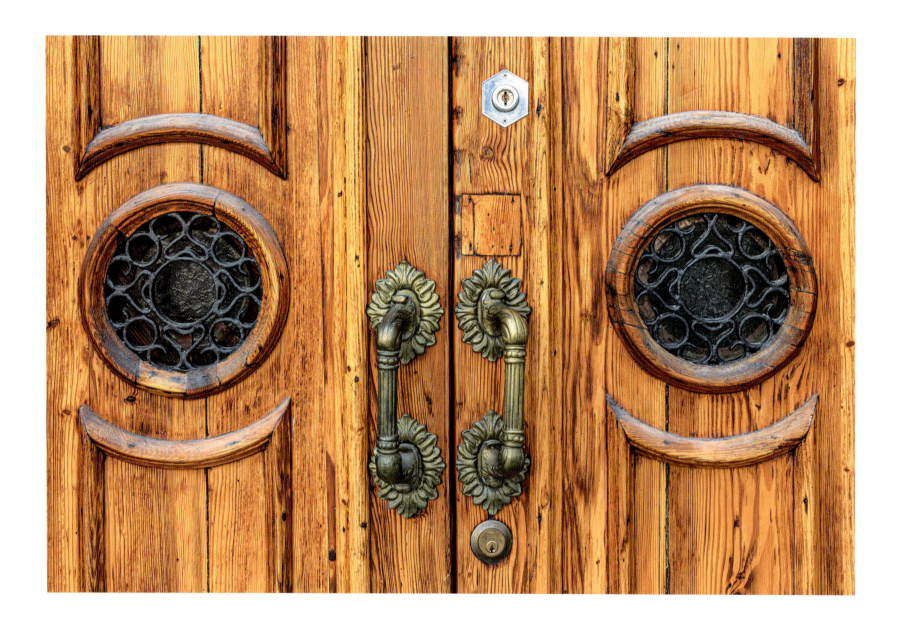

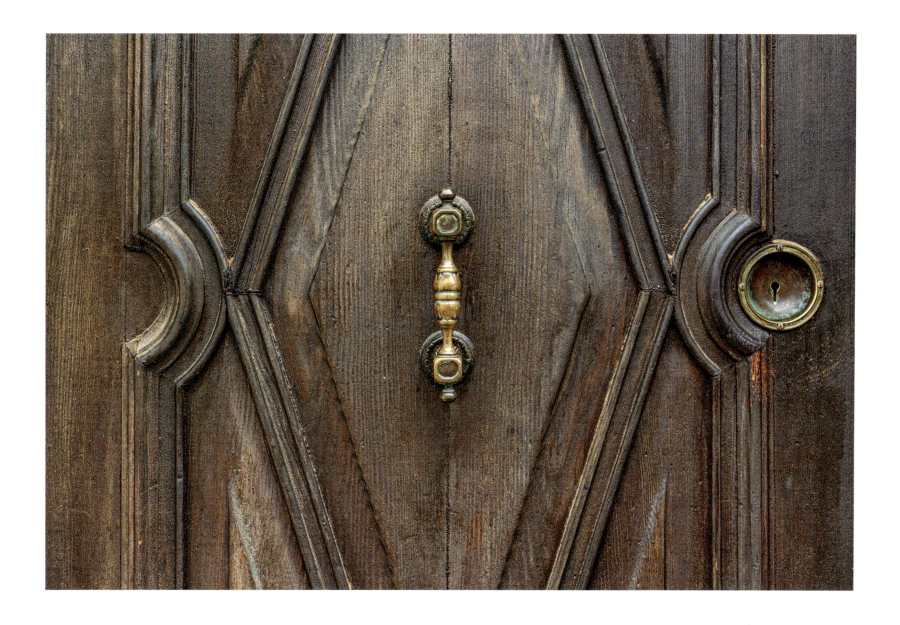

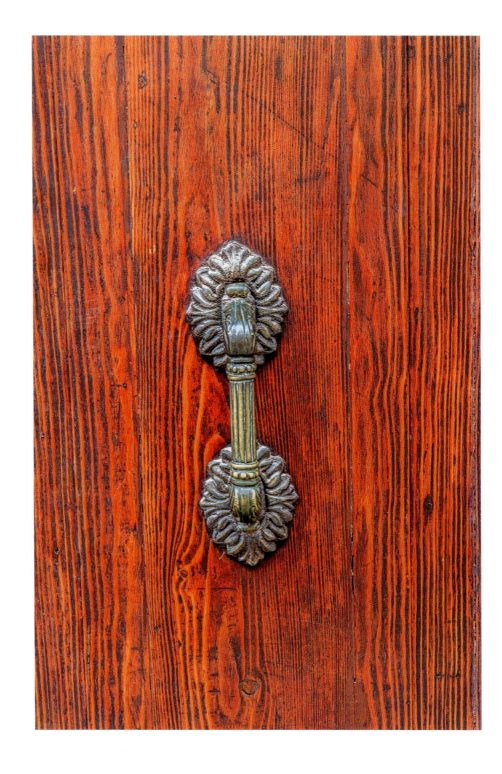

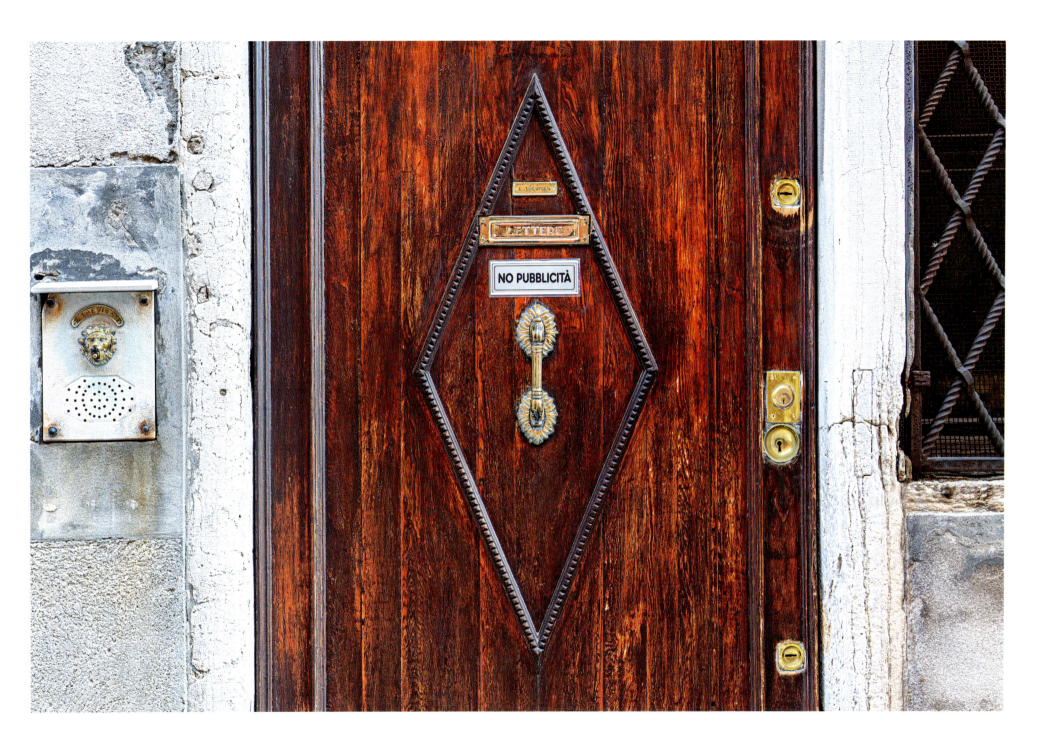

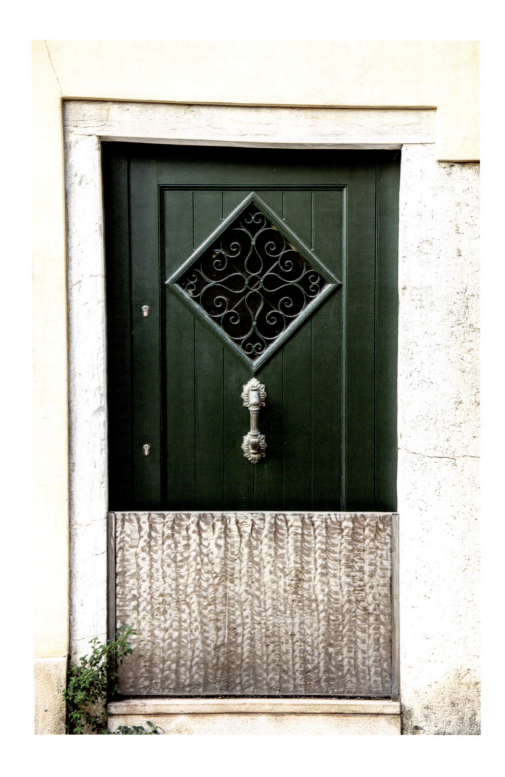

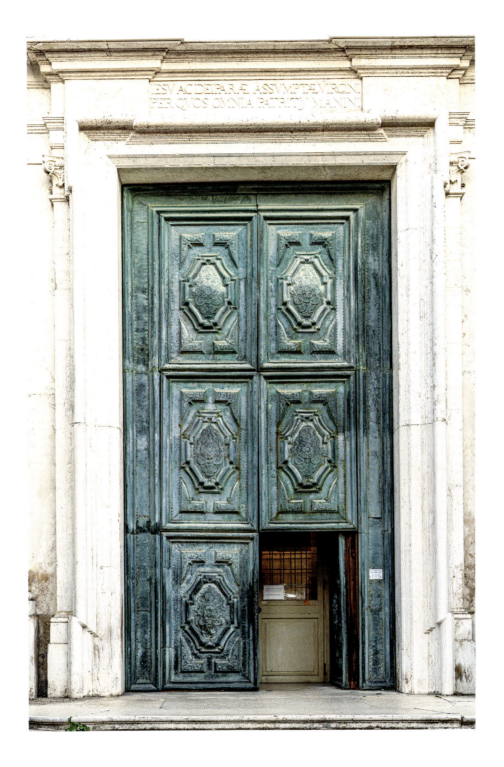

Church of Santa Maria Assunta, Cannaregio

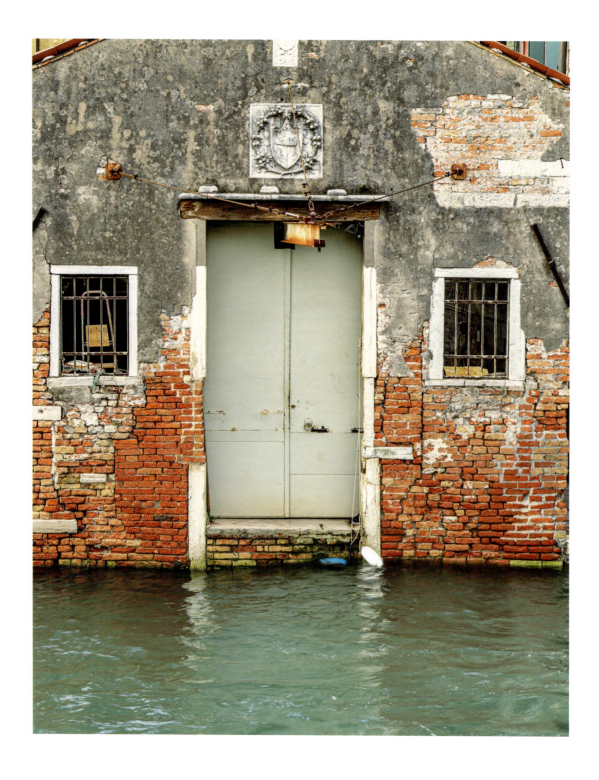

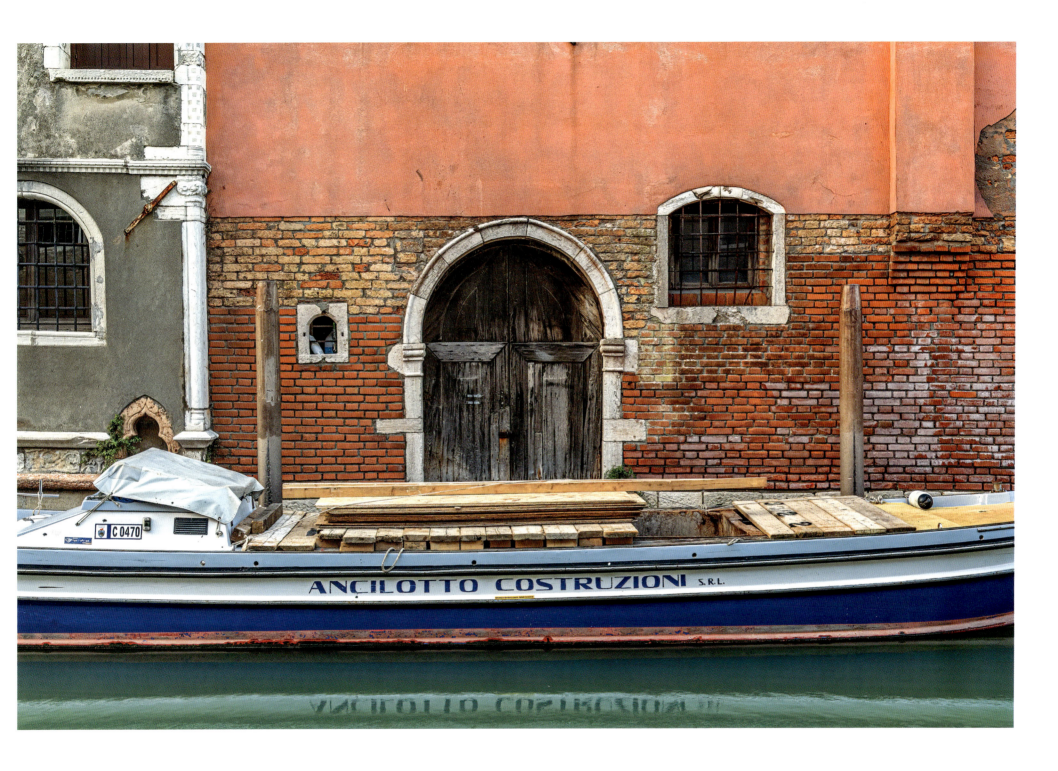
Canal door and construction barge, Santa Croce

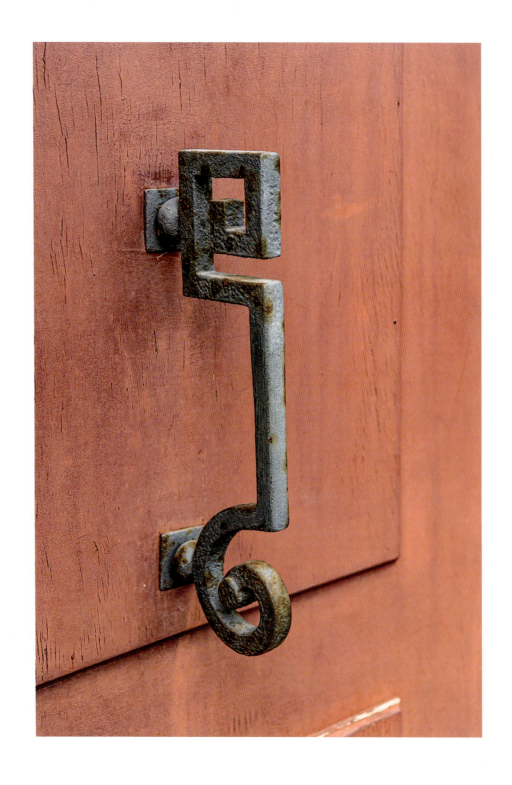

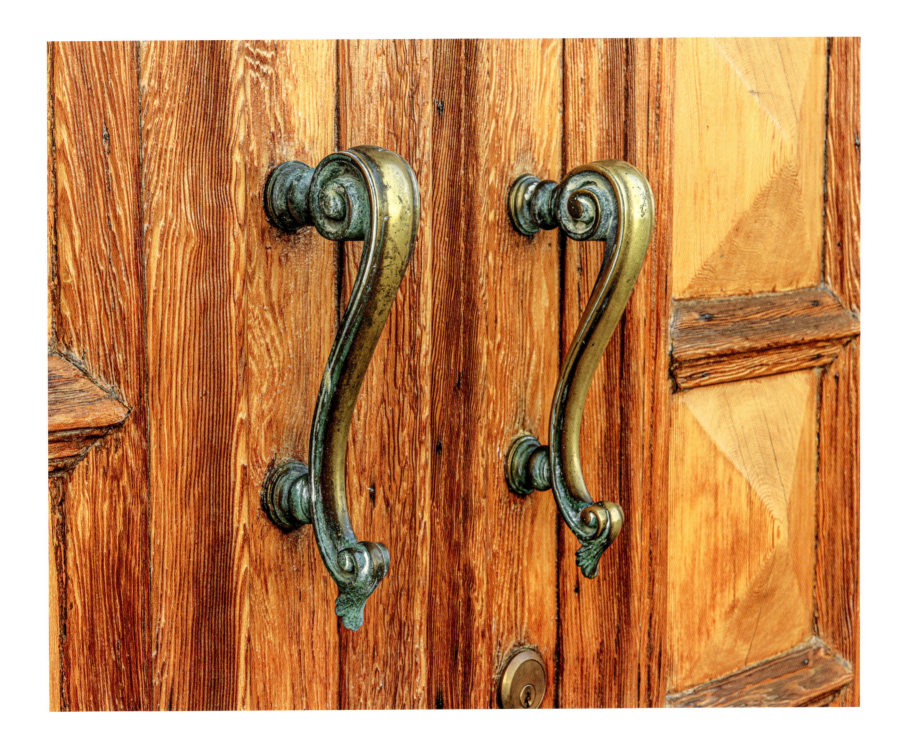

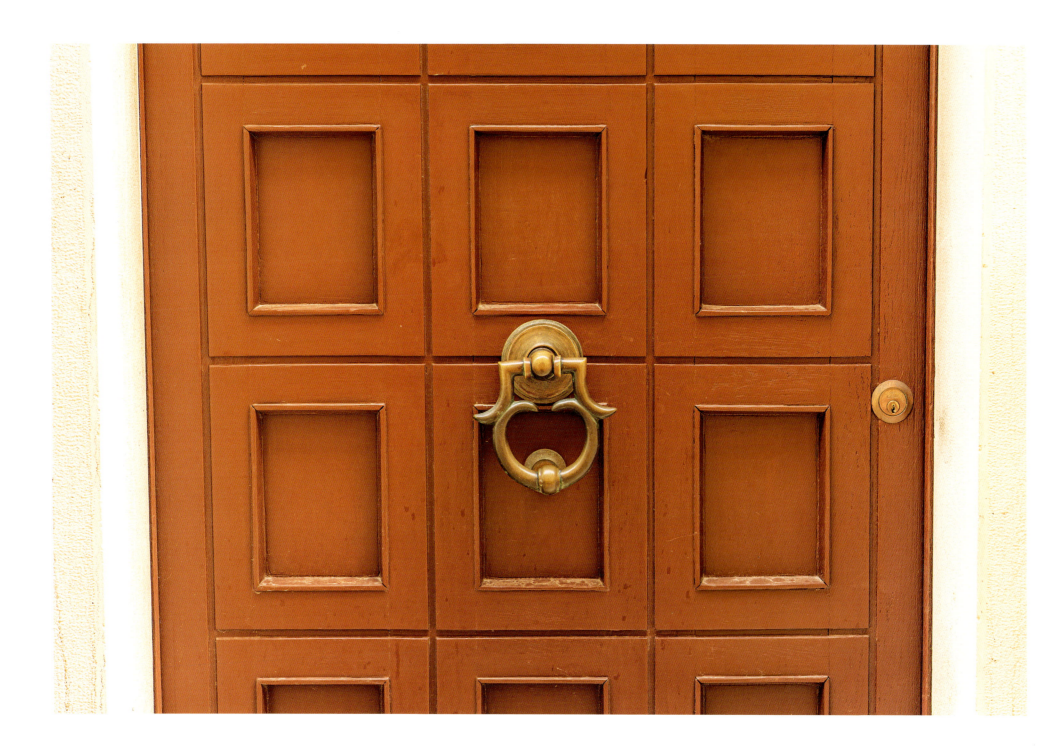

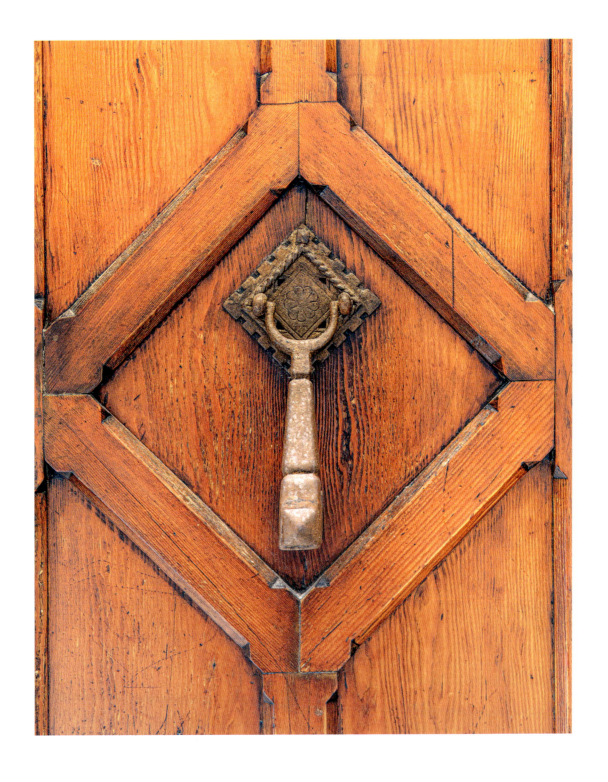

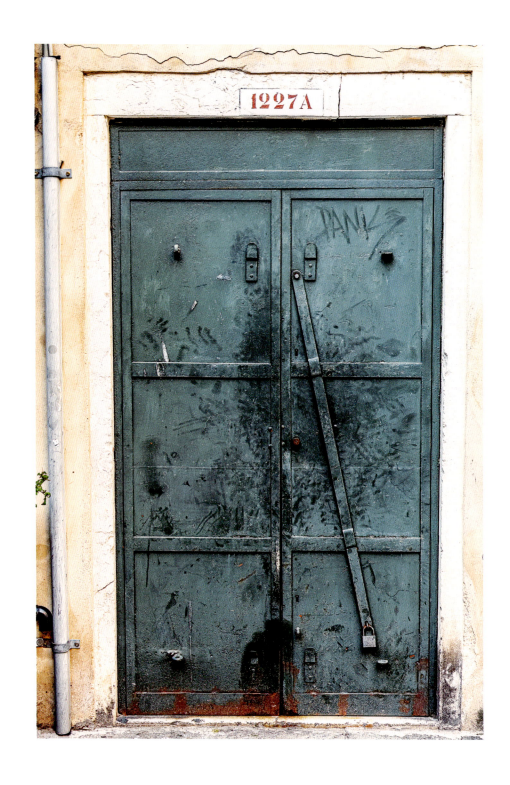

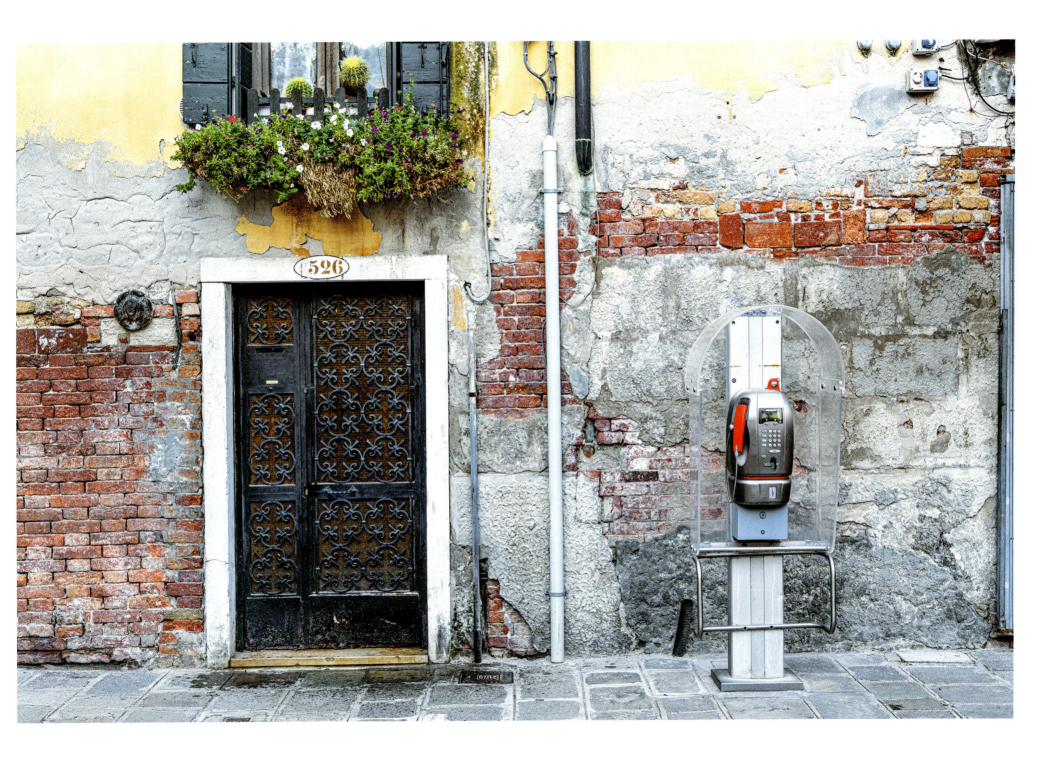

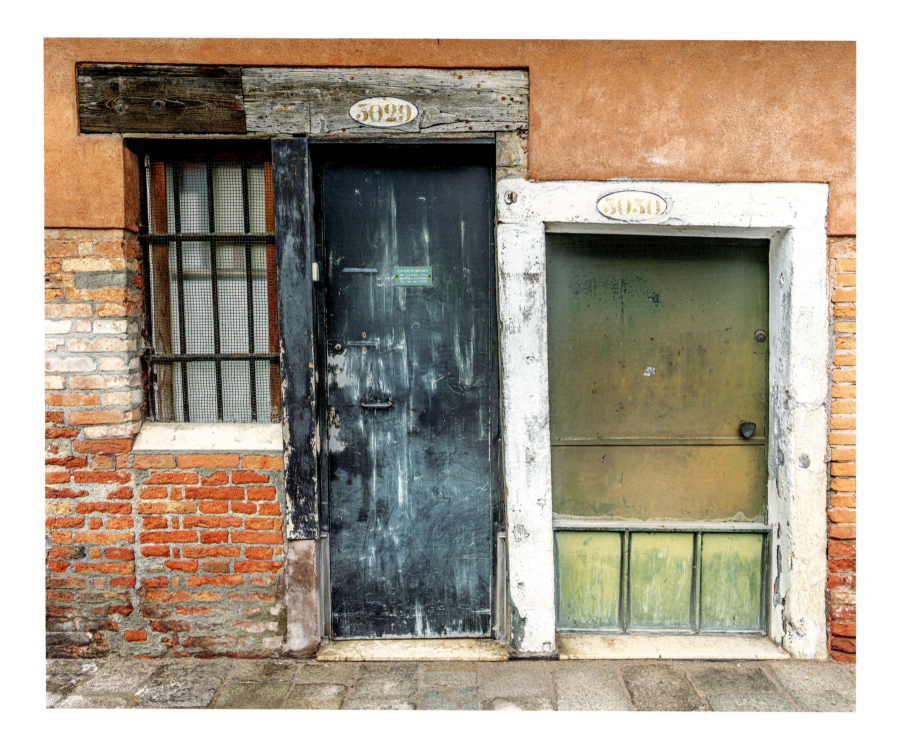

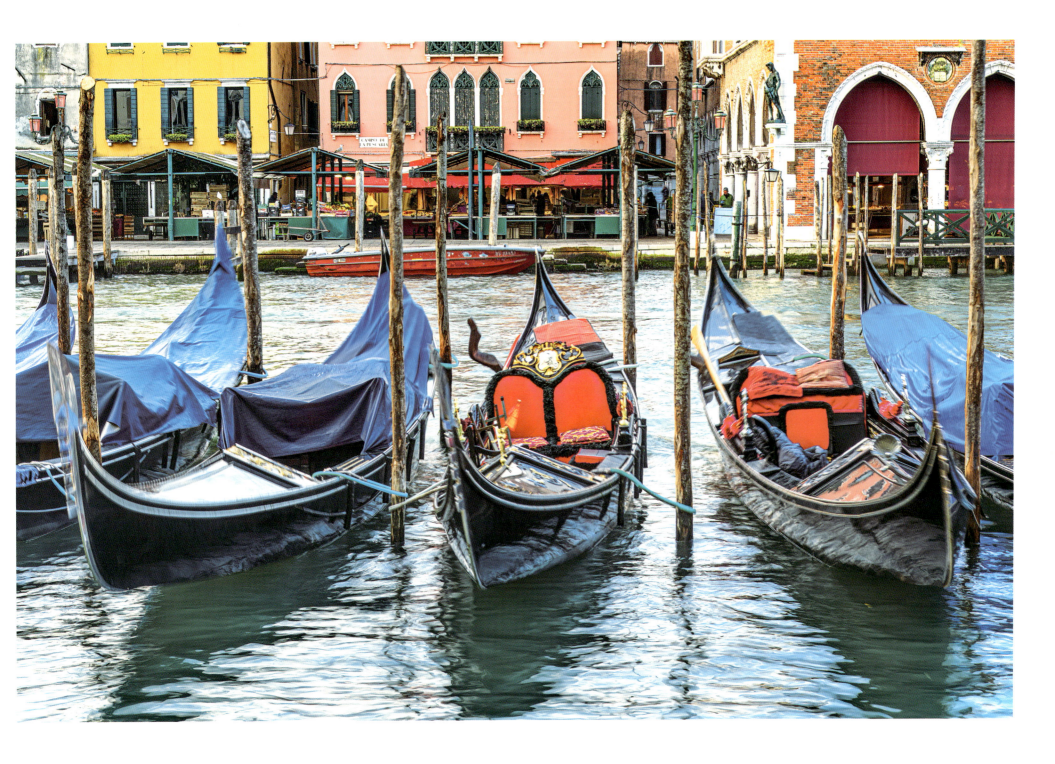

Gondolas on the Grand Canal across from the Rialto Market

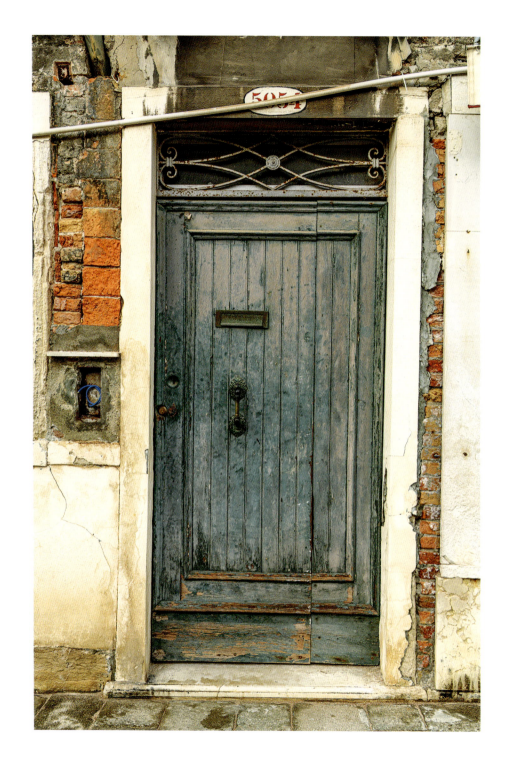

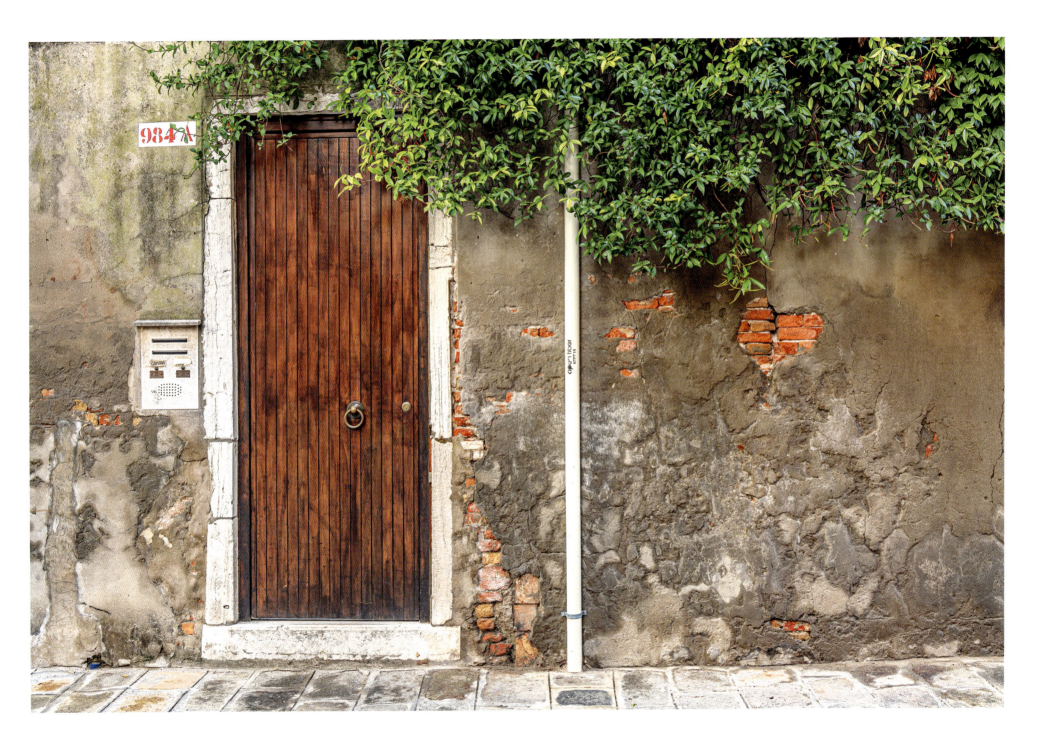

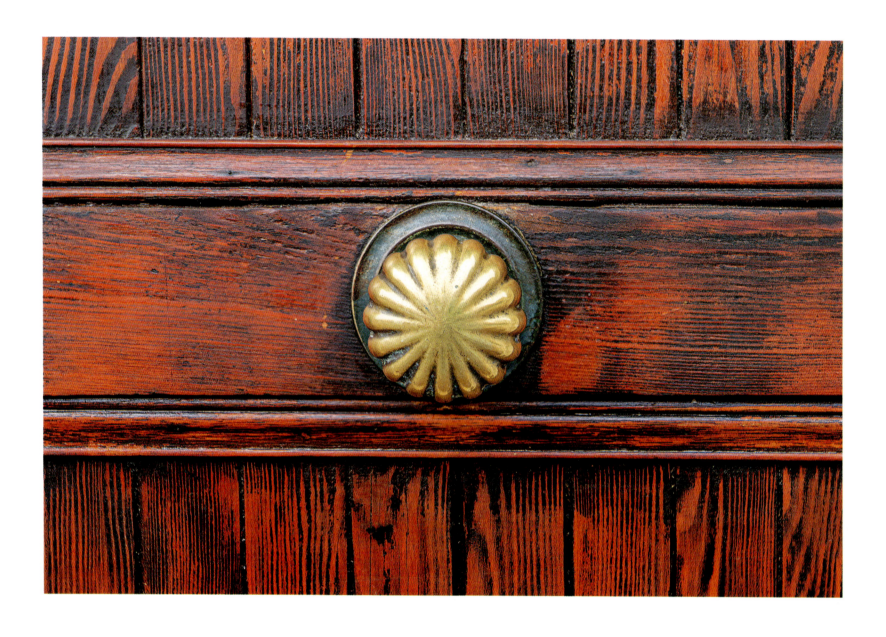

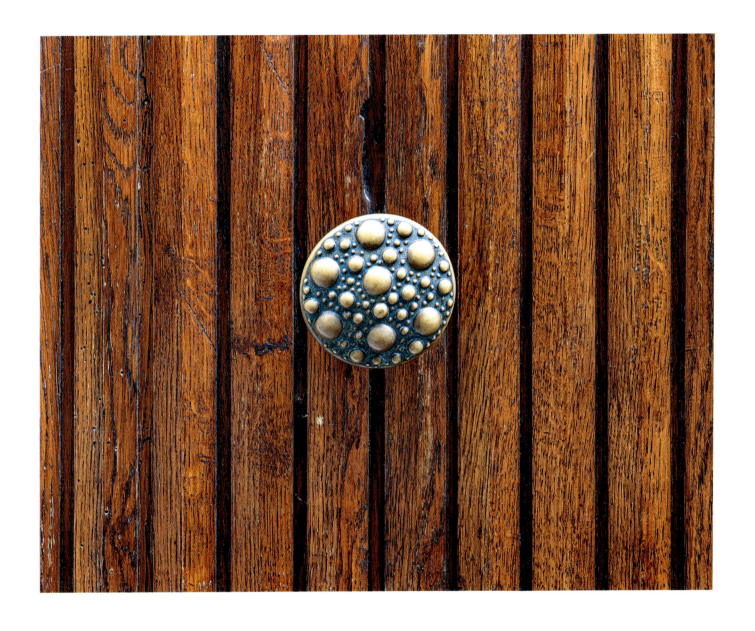

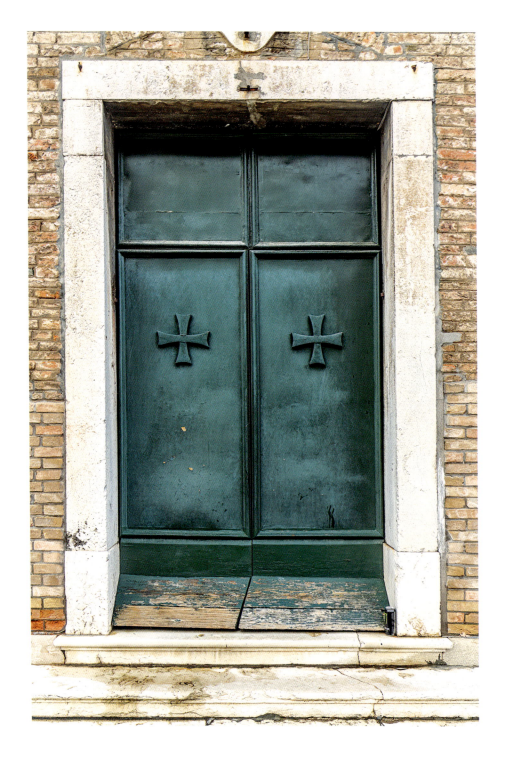
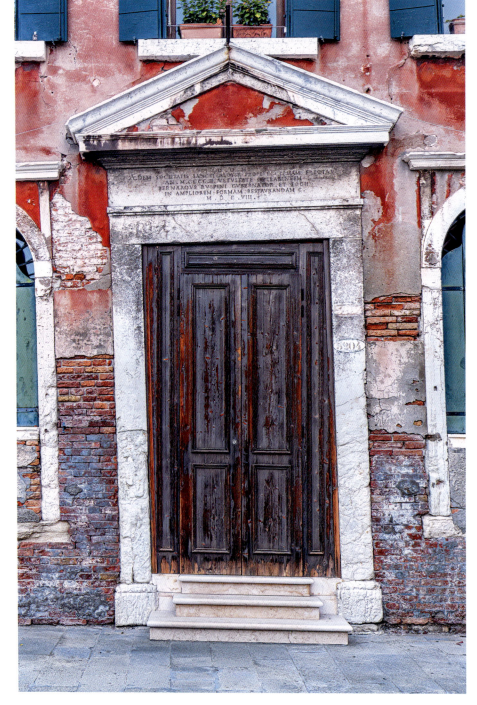

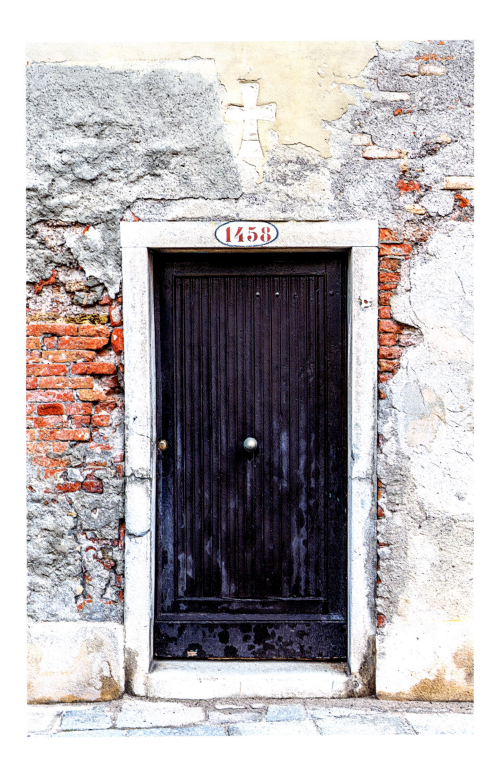

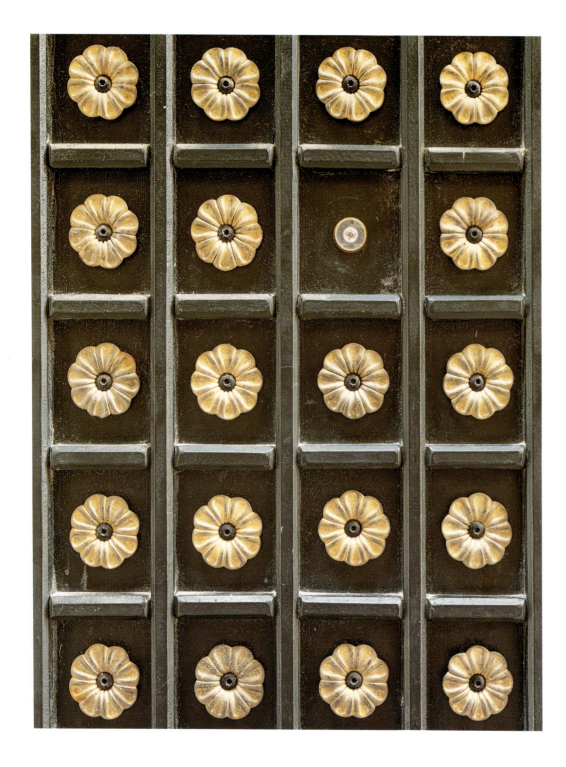
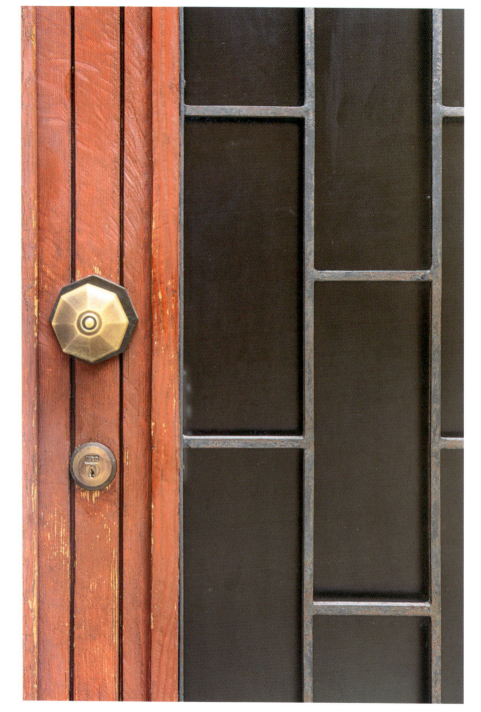

Acknowledgments

As with any significant project, there are many people to acknowledge, without whose participation this book would not exist. First, a heartfelt thank-you to the residents of Venice, who tolerated my presence with grace and patience. Most of the photographs in the book were made very deliberately, which translates to requiring a great deal of time. I would carefully position my tripod in just the right spot, mount my camera, frame the composition very deliberately, and then make the exposure, which was often around thirty seconds. I cannot tell you how many times, during or after this process, a surprised resident would open the front door from the inside and be surprised by my tripod, camera, and me standing right in front of him. Or I would finish the exposure, grab my rig, and turn around only to discover that a resident was standing there with an armful of groceries, patiently waiting for me to finish what I was doing. Never did I see a sneer or a snarl or hear a negative retort. The Venetians, whose city is under daily siege by tourists, are truly a welcoming people.

I feel special and sincere gratitude to my small team of personal advisors, whom I can always count on for an honest and thoughtful opinion. Carolyn Casey built the foundation for the book with her design and layout skills. I clearly had no business doing this myself, and the book would have been substantially less elegant without her involvement. James Bleecker, an accomplished fine-art photographer, has been a mentor to me, in many ways, for many years. He has been very generous with his time in critiquing concepts and photographs. James has been the most significant force behind whatever photographic skills I have achieved over the years. I thank Christine Velardi for her opinions and for her patience with me during the creation of the book. Venice and the book have been constant material of conversation and had to have been at least a little difficult to tolerate at times. Last, but not least, my thanks go to Chiu Yin Hempel. I have leaned heavily on Chiu Yin over the years for publishing matters, and especially with this book. Chiu Yin has always been there with generosity and selflessness. Her advice and knowledge are things I know I can always trust implicitly, and her presence is felt throughout the book.

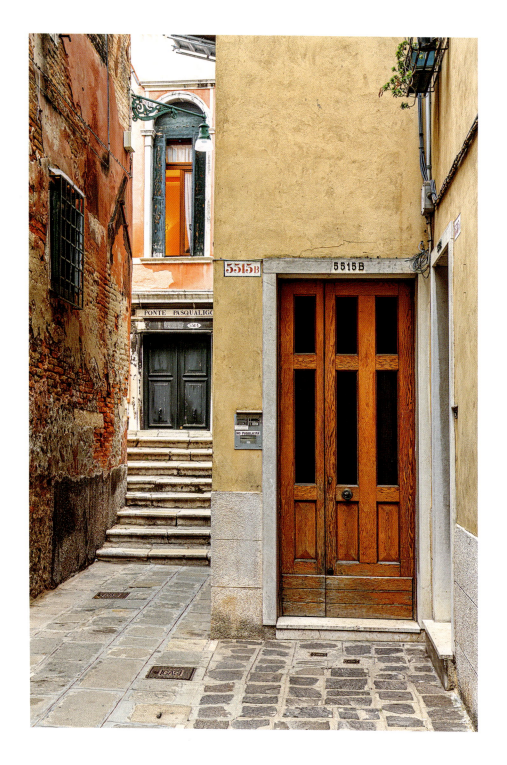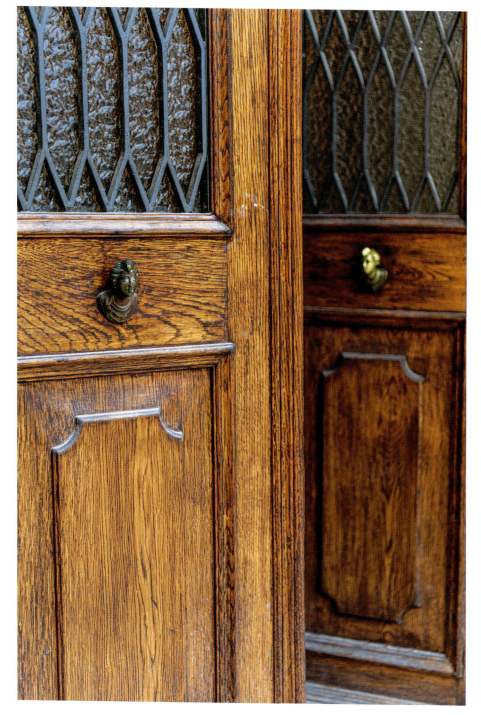

Greg Miller photographs a wide range of subjects, from bold and colorful landscapes to intimate, monochromatic artistic nudes with subtle textures and tones. Commercial assignments have ranged from New York's Adirondacks to Chilean Patagonia. Miller has previously published three award-winning photography books.

Miller was honored by being selected as one of three artists represented in the inaugural limited-edition Artist Portfolio by the Samuel Dorsky Museum of Art. Miller's photographs have been featured in publications such as *Popular Photography*, *Outside*, *B&W* (*Black and White*) magazine, *Photo District News*, Europe's *DIGIfoto* magazine, *Hudson Valley*, *Budget Travel*, *Outside*, *Outdoors*, *Backpacker*, *Elements*, and *InsideOut Hudson Valley*. Miller has led workshops for organizations such as the Center for Photography at Woodstock, Peters Valley Craft Center, and National Park Service. He lives in Middletown, New York.

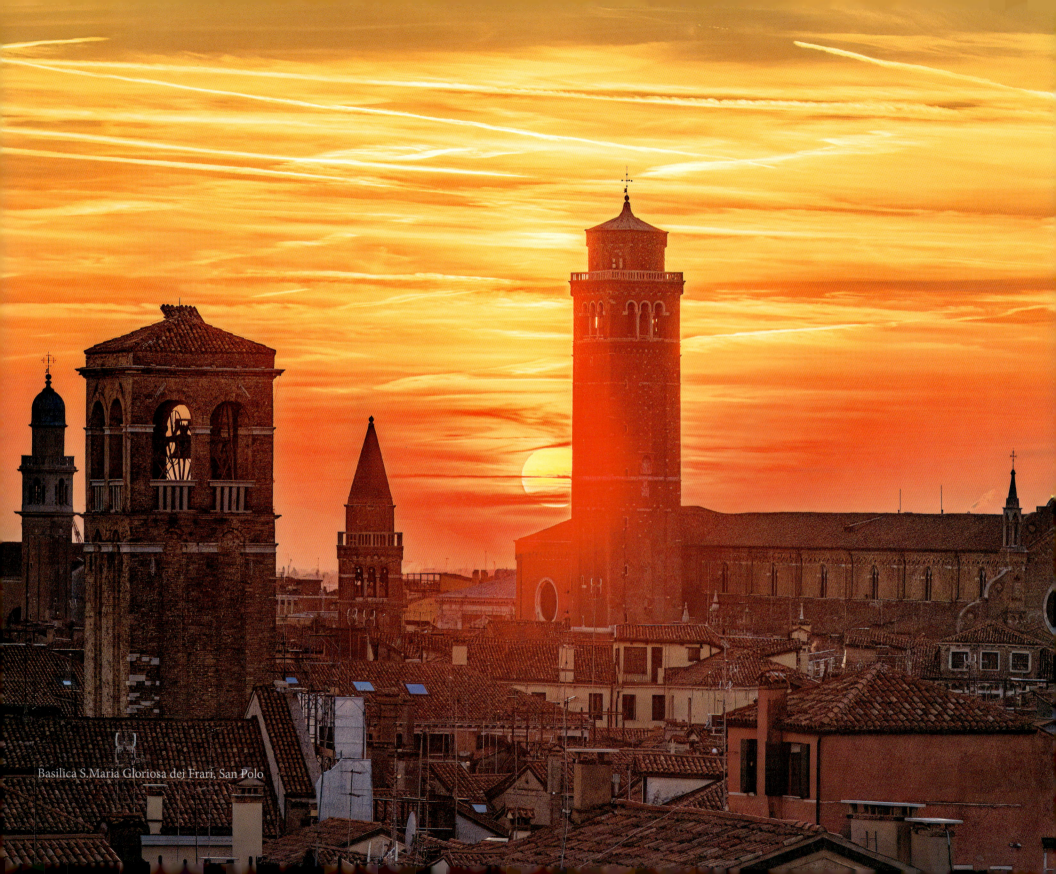
Basilica S.Maria Gloriosa dei Frari, San Polo